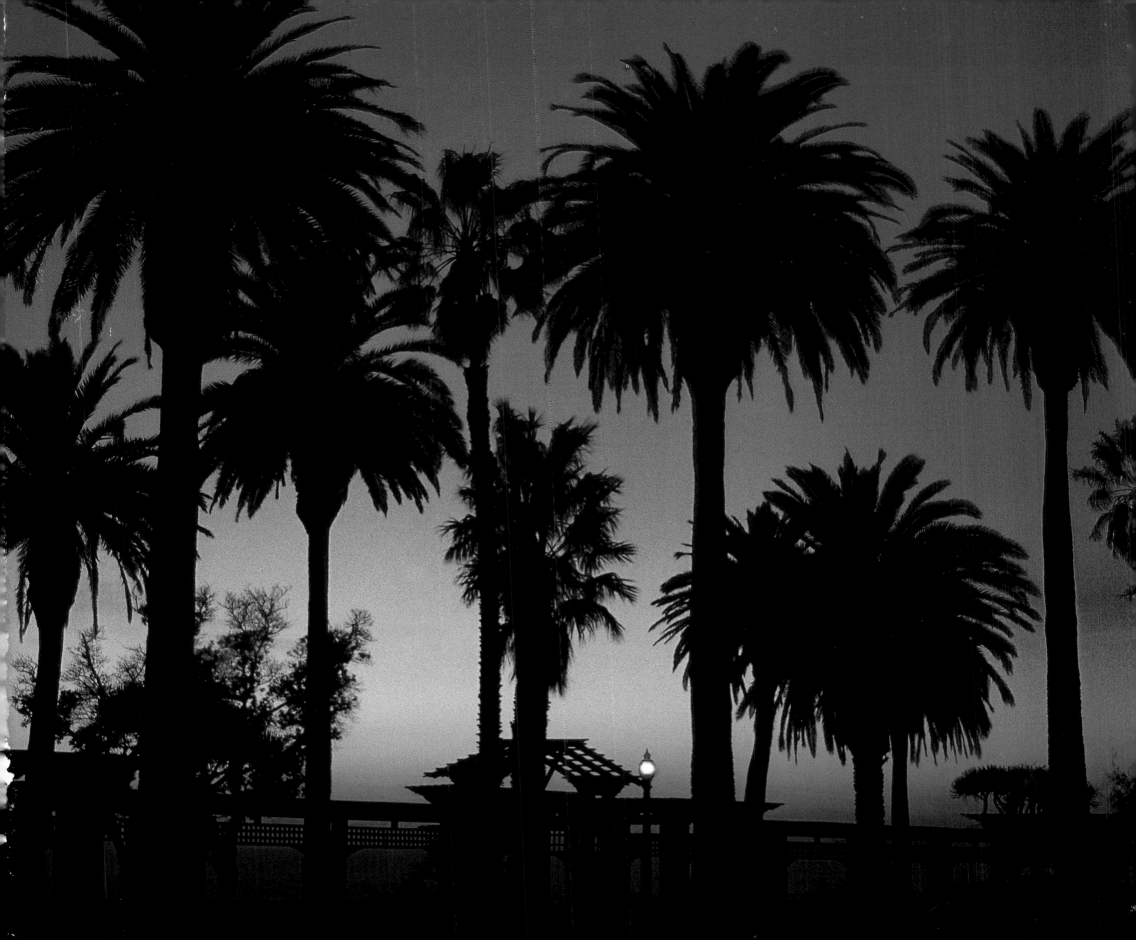

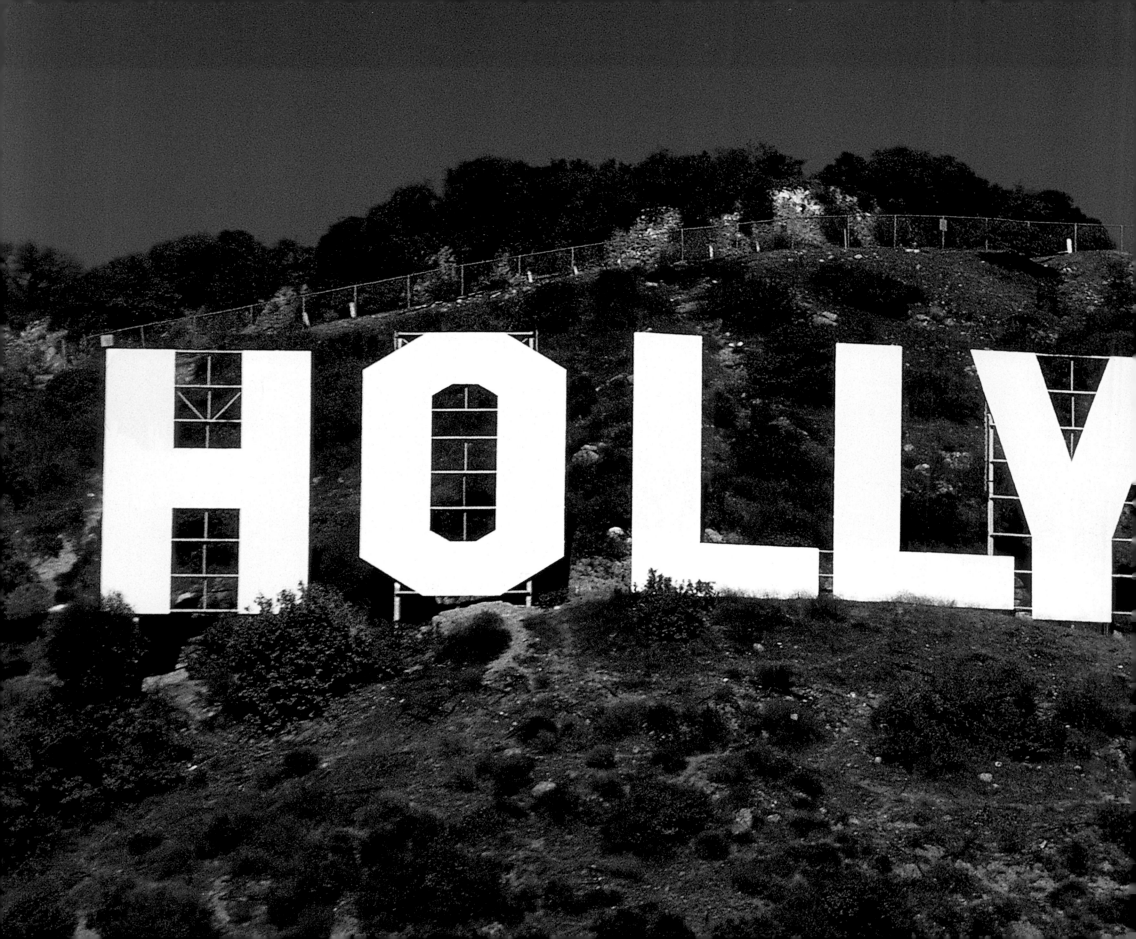

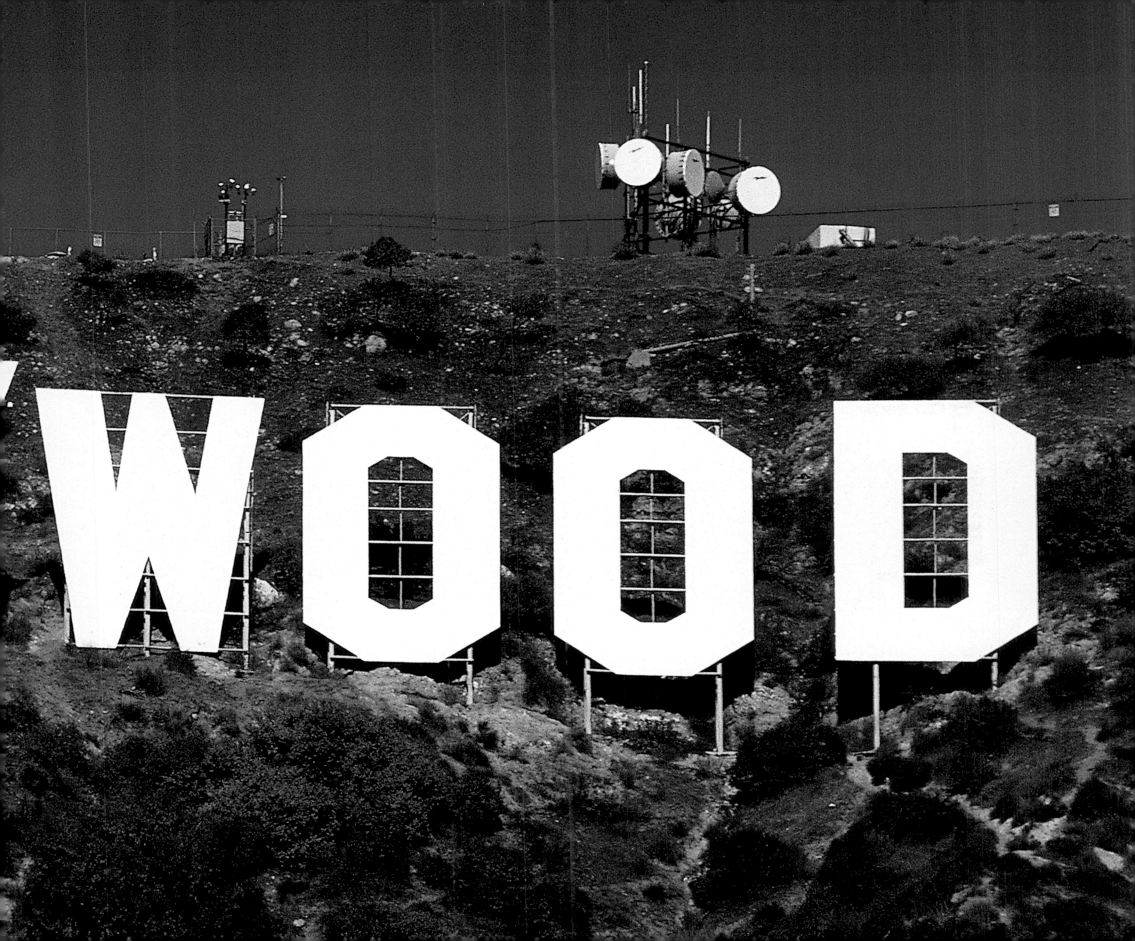

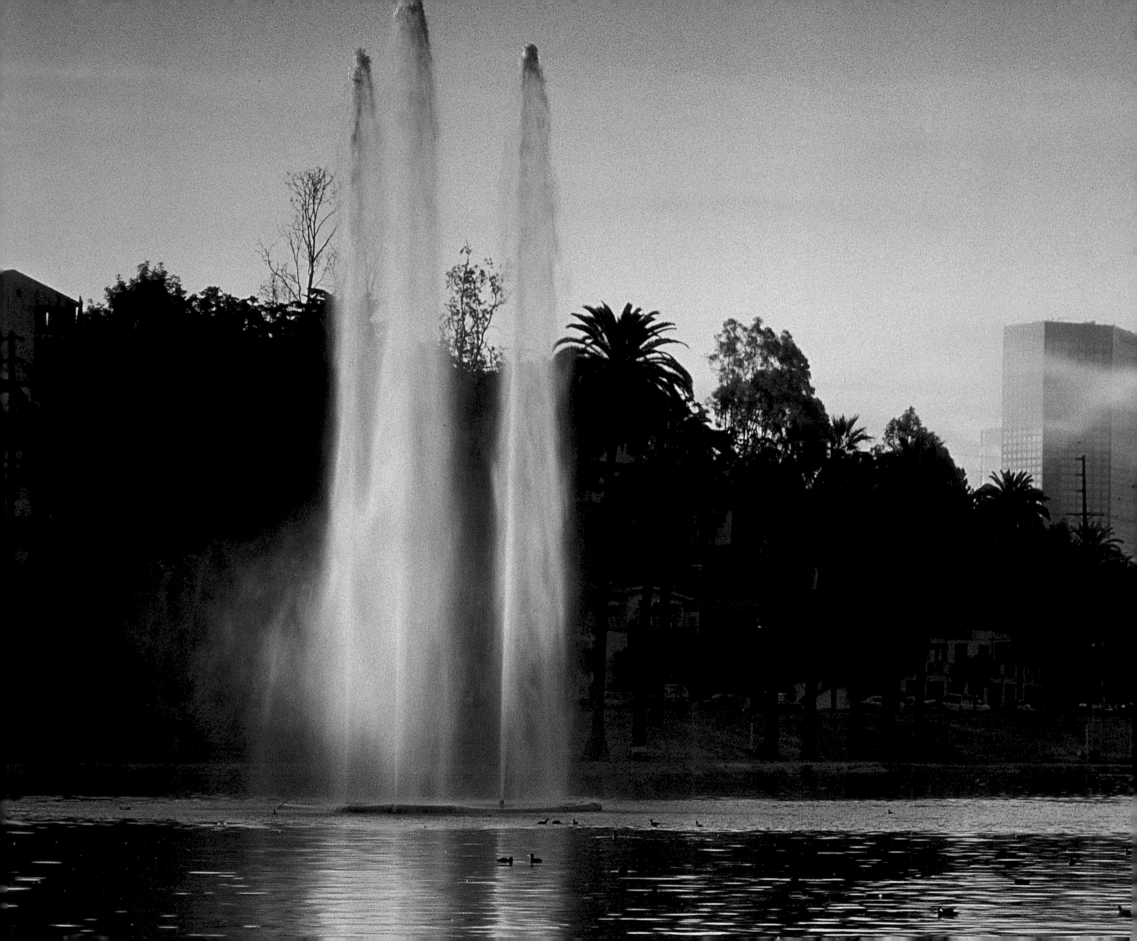

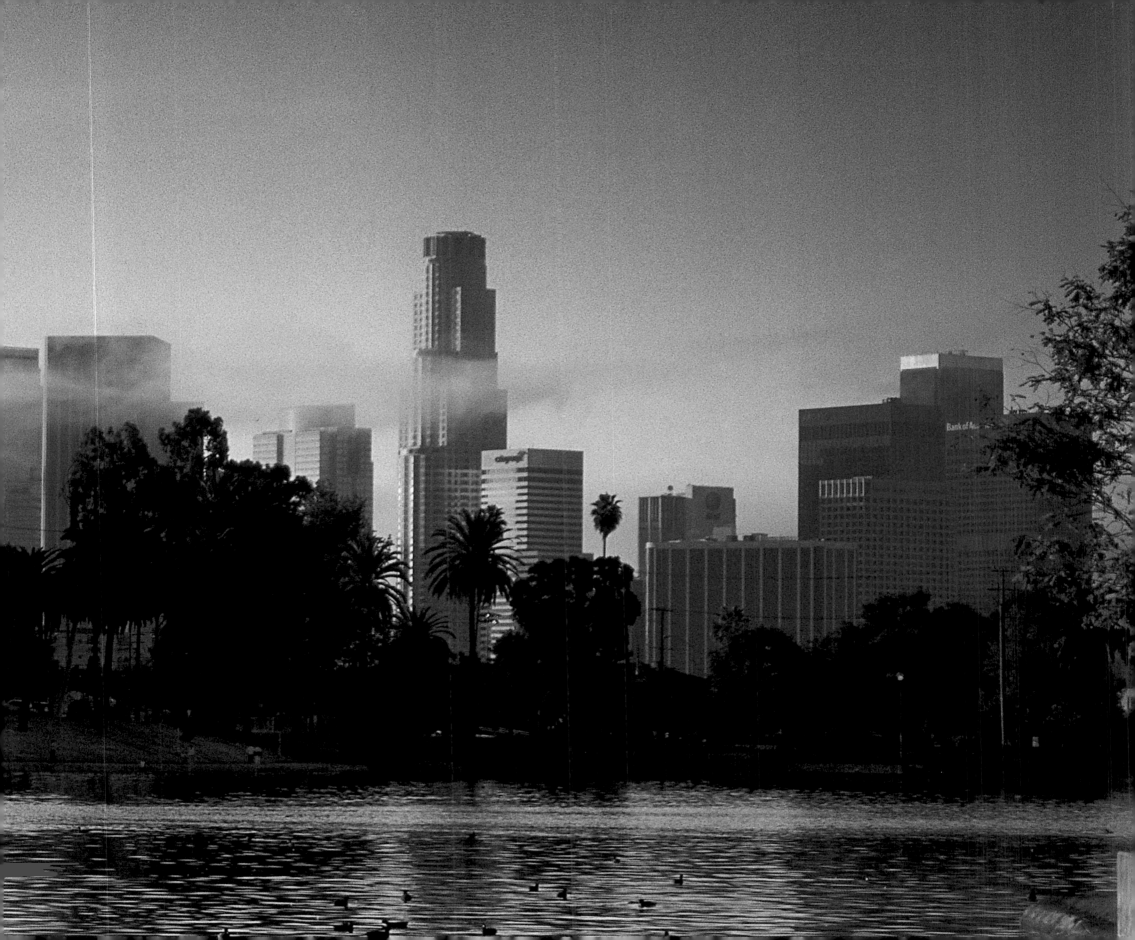

Previous pages: The Hollywood Sign; The L.A. skyline at dawn from Echo Park.

About the Author

California-based photographer Andrew Hudson spent a year researching and photographing Los Angeles. This is his eighth book about the Golden State.

Andrew's awards include the Benjamin Franklin Award for Best First Book and the Grand Prize in the National Self-Published Book Awards.

Born in England, Andrew lives in San Diego with his Los Angeles County-born wife, L.A. Woman and Valley Girl, Jennie.

The Hollywood Sign and the Hollywood Walk of Fame are TM/2001 Hollywood Chamber of Commerce, licensed by Global Icons, Los Angeles CA 90034. All Rights Reserved. Used with permission. www.globalicons.com. Thanks to Jill Nadley.
Images and trademarks of Universal Studios © 2000 Universal Studios. Used with permission. Thanks to Eliot Sekular.
Disney characters © Disney Enterprises, Inc. Photographs of Disneyland® Resort (pages 18–21) used by permission from Disney Enterprises, Inc. Thanks to Margaret Adamic.
"Venice Reconstituted" mural © Rip Cronk. Used with permission. Images and trademarks of Six Flags Theme Parks Inc. ®, TM and © 2001. Used with permission. Thanks to Andy Gallardo.
SUPERMAN attraction name trademark of DC Comics © 2001. The Getty Center requested not to be included in this book. Academy Award(s)®TM of AMPAS. Tony Award(s)®TM of ATW.

Published by
PhotoSecrets Publishing
8503 H Villa La Jolla Drive
La Jolla CA 92037-2305
www.photosecrets.com
www.aphototour.com
Printed in Korea.

Stock photos and additional books are available. Contact: andrew@andrewhudson.com
Tel: 858-546-9276.

First edition 2001.
Copyright © 2001 Andrew Hudson / PhotoSecrets Publishing. No portion of this book may be reproduced without written permission.

Distributed to the trade by National Book Network (NBN), tel: 800-462-6420.
ISBN 1-9304595-33-1 (pk.)
ISBN 1-9304595-34-X (cl.)

A Photo Tour of

Los Angeles

By

Andrew Hudson

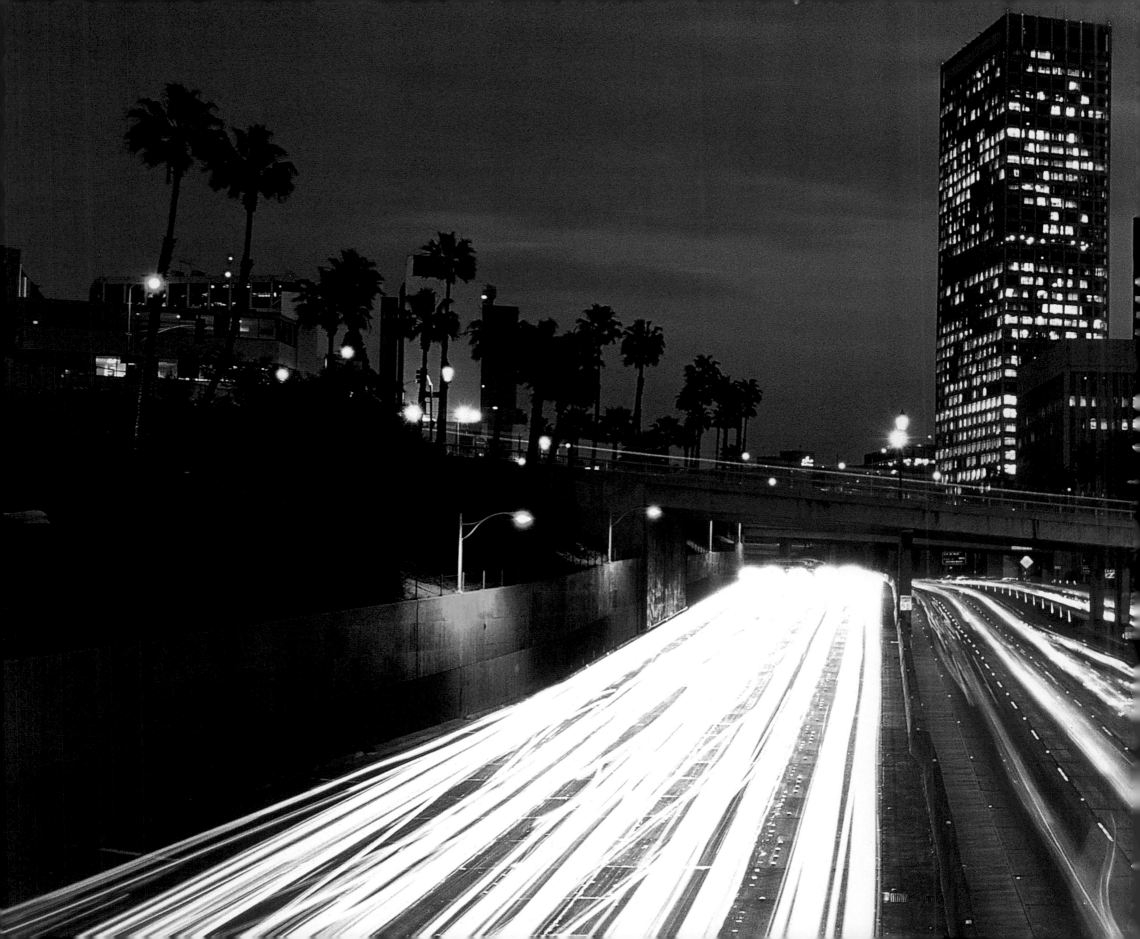

Contents

Hollywood10

Universal Studios16

Disneyland19

Santa Monica and Venice 22

Beverly Hills30

Griffith Park38

Downtown42

Magic Mountain54

Long Beach and

 The Queen Mary56

Aquarium of the Pacific .60

The Huntington66

Hollywood

"Hollywood is a town that has to be seen to be disbelieved."
— *Walter Winchell*

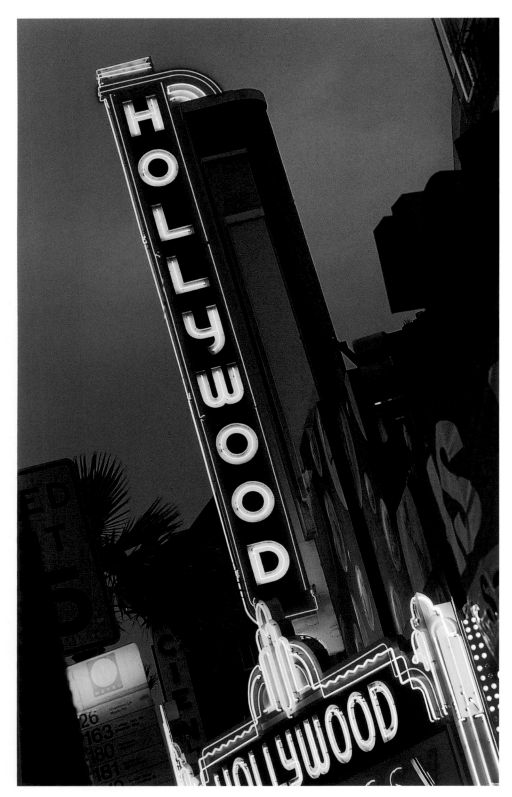

lamour, glitz, and celebrity all have one address: Hollywood. Around the globe, the name conjures images of star sightings, movie magic, fantasy, fame and fortune. Robert Redford called it "the end of the rainbow, the melting pot, the edge of the continent."

During the Golden Age of Hollywood, in the 1920s and 1930s, most of the major studios were based here. Stars cruised the fabled boulevard and movie premieres were held with great fanfare. Today, much of the industry has moved elsewhere but remnants of the past remain.

At Mann's Chinese Theater, over 150 celebrities have left their marks in the concrete forecourt and you can compare your

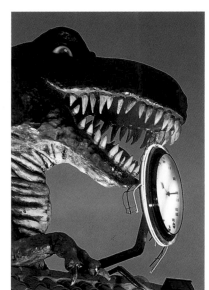

body to Harrison Ford's hands, Jimmy Durante's nose or Betty Grable's legs. Marilyn Monroe, Elvis Presley, and Tom Cruise can be found in the Hollywood Walk of Fame, a trail of 2,500 stars laid into the sidewalk. And high on the hill, the world's most famous sign proclaims in 50-foot-tall letters: "Hollywood."

The bright lights of Hollywood beckon stars and visitors alike.

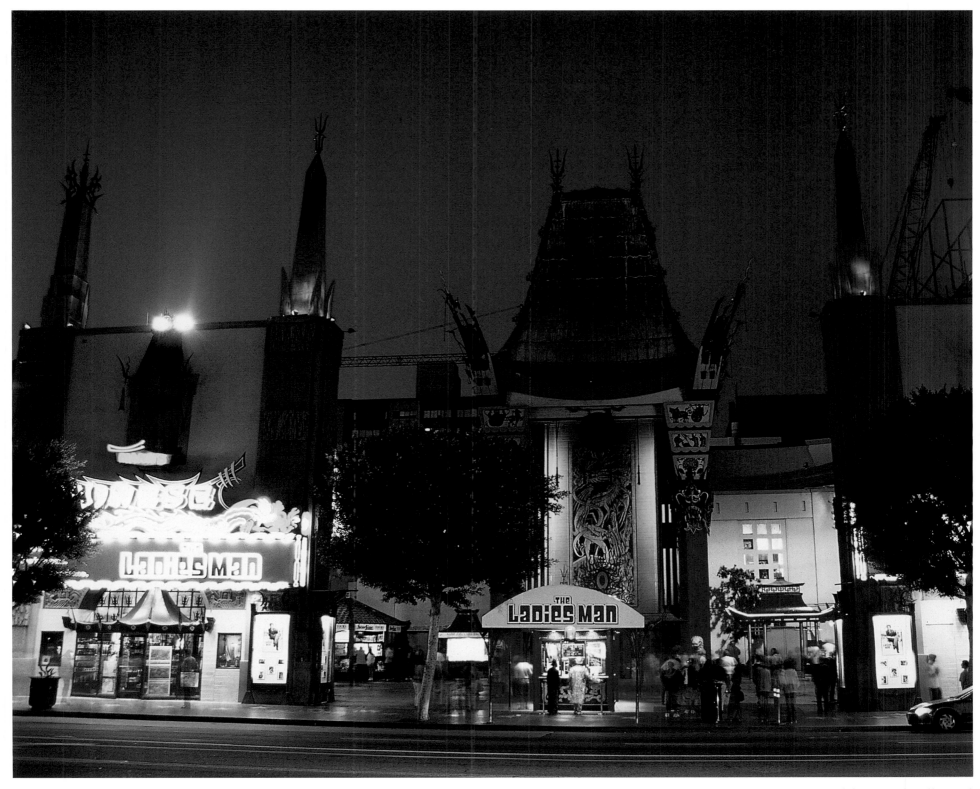

Built in 1927 by impresario Sid Grauman, Mann's Chinese Theater captures the spectacle and fantasy of Hollywood.

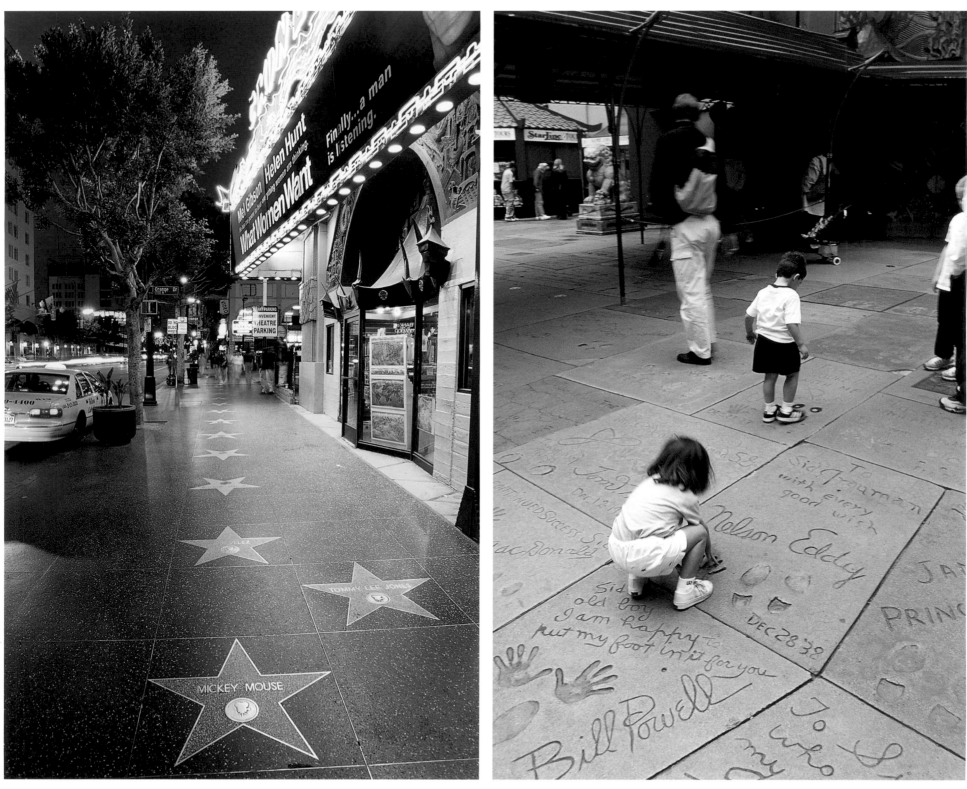

Reach for the stars on the Hollywood Walk of Fame and the forecourt of Mann's Chinese Theater.

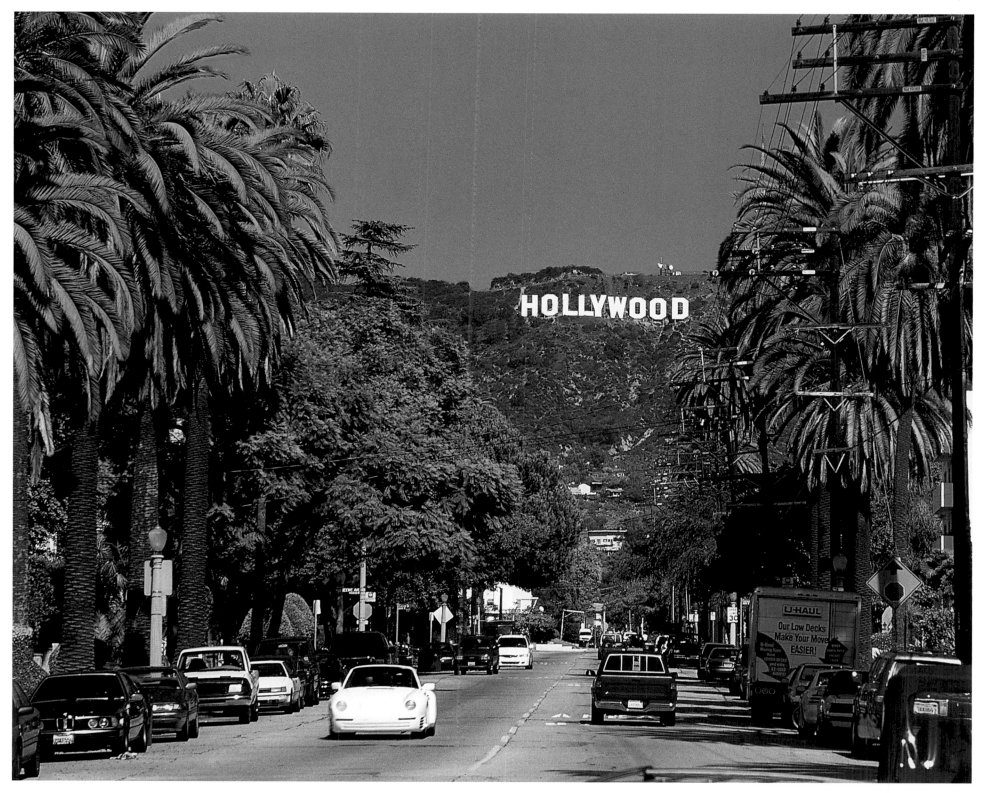

Erected as a real estate promotion in 1923, the Hollywood Sign now symbolizes America's movie industry.

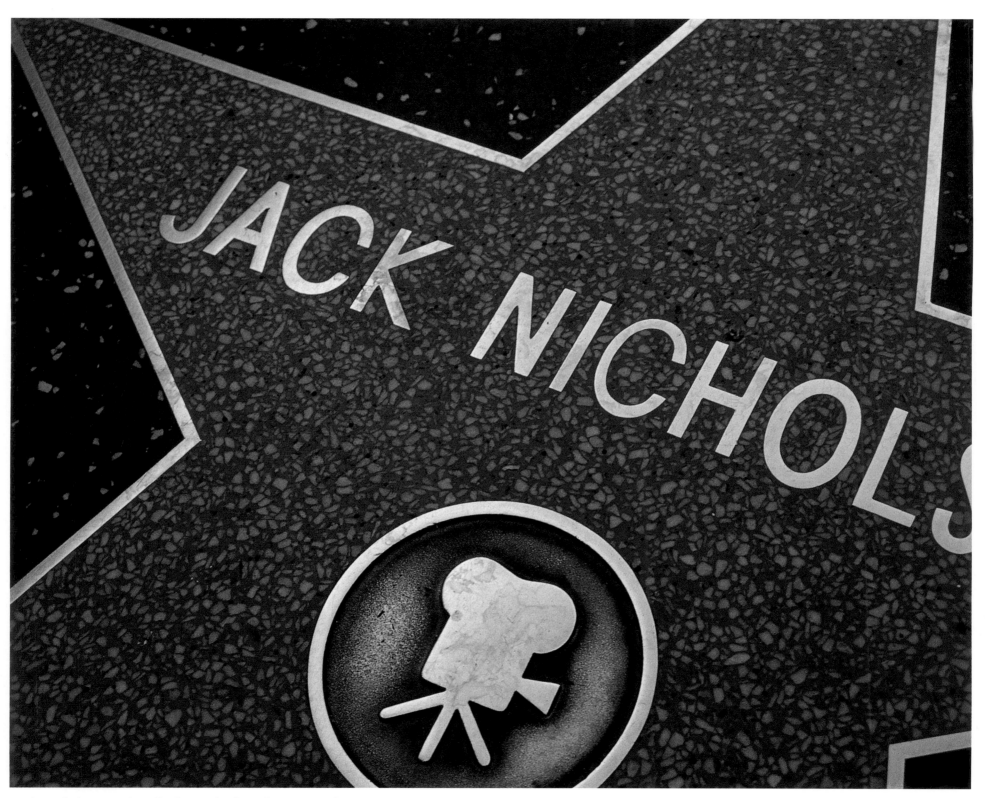

Jack Nicholson can handle the truth about his star on the Hollywood Walk of Fame.

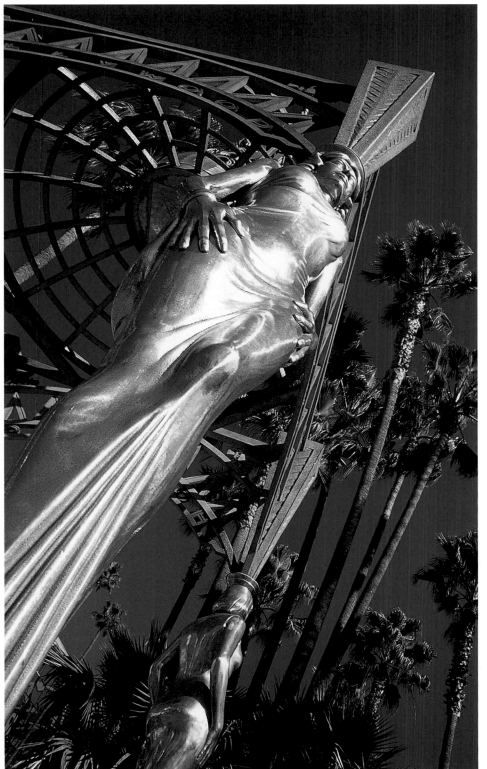

Sights of Hollywood.

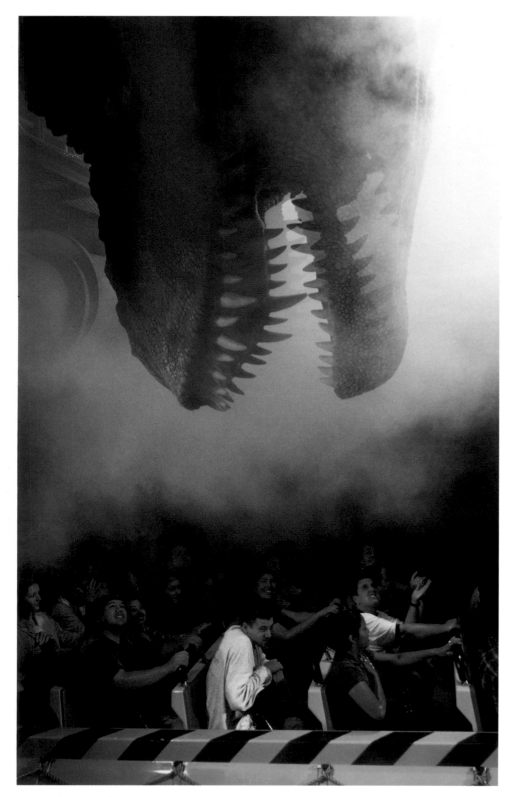

Universal Studios Hollywood

"You're in Hollywood now."

Become a movie star by entering the world's largest film and TV studio. As the cameras roll, you can tour the 415-acre backlot and glimpse the secrets and thrills of movie-making. Dating from 1915, Universal is one of the oldest continuously operating movie studios and is today the most popular attraction in Los Angeles County.

The famous Backlot Tour takes you through the actual sets from such classic movies as E.T., Back to the Future, Spartacus, and The Sting. Drop by Psycho's Bates Motel, experience an 8.3 earthquake, get attacked by Jaws, and come face-to-face with King Kong.

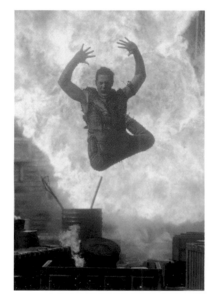

Exciting rides allow you to step into the movies at Terminator 2:3D, WaterWorld, and the pyrotechnic furnace of Backdraft.

Meet the star of Jurassic Park — The Ride.

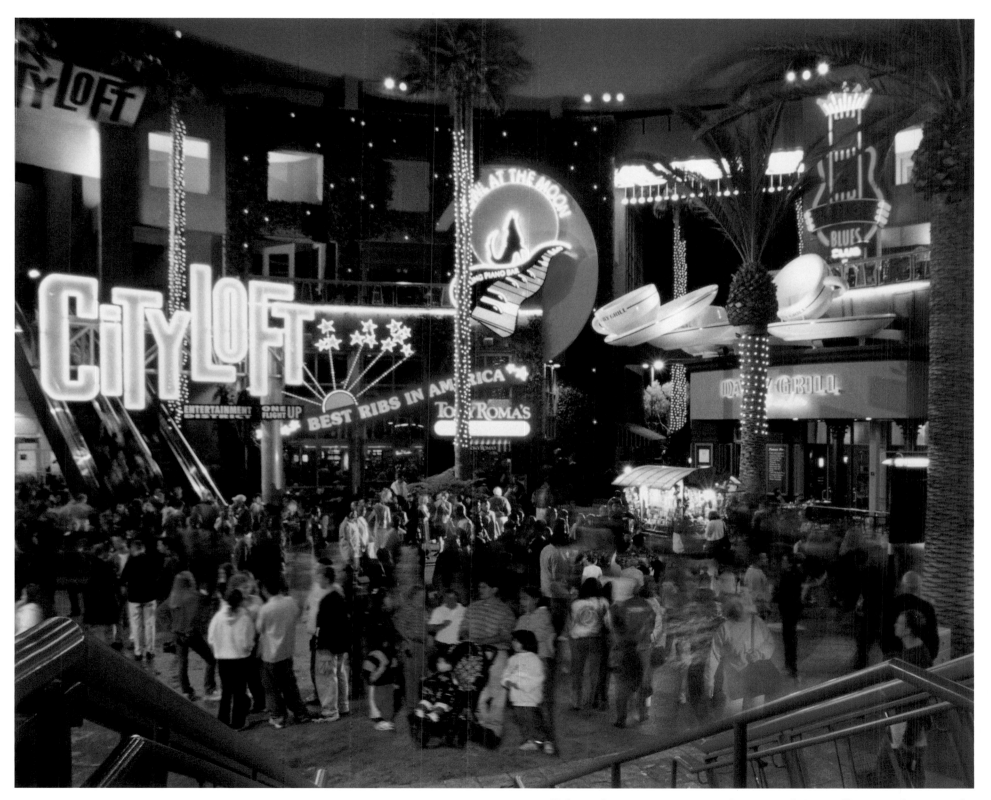

"The coolest street in America," Universal CityWalk comes alive at night.

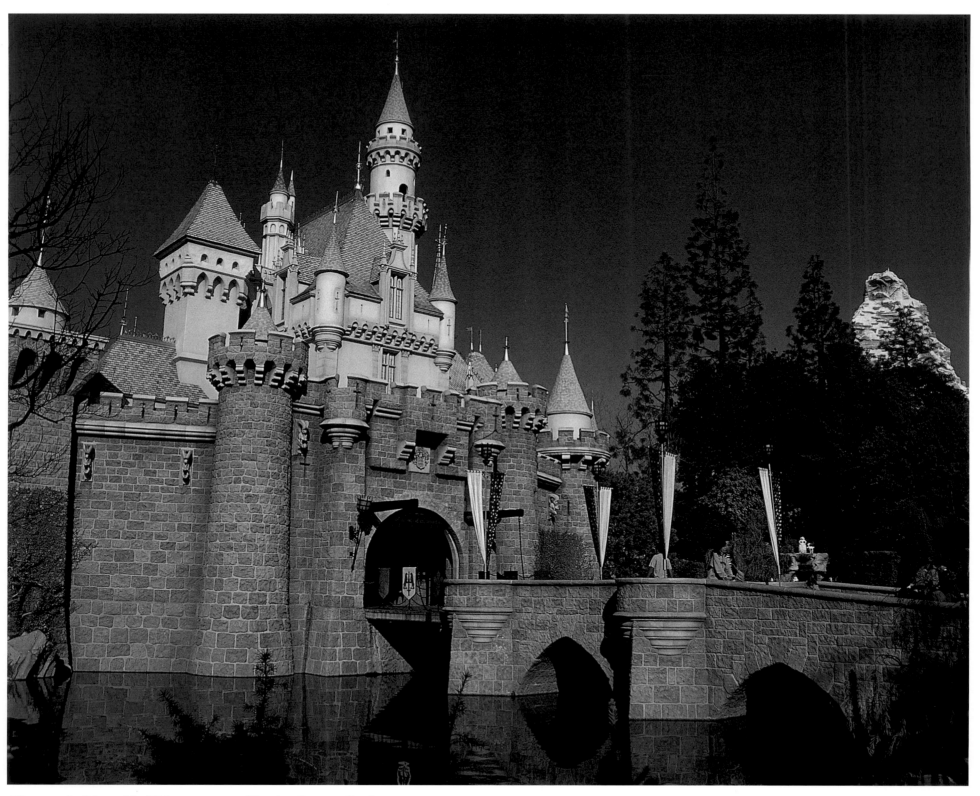

The wonderful world of Disney starts at Sleeping Beauty Castle.

Disneyland® Resort

"The Happiest Place On Earth!"
— *Creator Walt Disney*

The world's first theme park, Disneyland still reigns as the home of imagination and wonder. Children's eyes light up when they get a handshake from Mickey Mouse, an autograph from Cinderella, and a hug from Winnie the Pooh. This is truly the Magic Kingdom.

Radiating from Sleeping Beauty Castle, eight Disney 'lands' await you, each with intricately themed rides. Fly through the dark space of Space Mountain in Tomorrowland; avoid a rolling ball of rock in the Indiana Jones Adventure in Adventureland; meet the pillaging Pirates of the Caribbean in New Orleans Square; survive a runaway train on Big Thunder Mountain Railroad in Frontierland; get soaked on Splash Mountain in Critter County; escape to Fantasyland and the delights of It's A Small World; step into a cartoon in Mickey's

Toontown; and stroll along Main Street, U.S.A., a re-creation of Walt Disney's boyhood home.

The 1955 park was joined in 2001 by Disney's California Adventure park — an upscale tribute to the Golden State — and the nighttime delights of Downtown Disney.

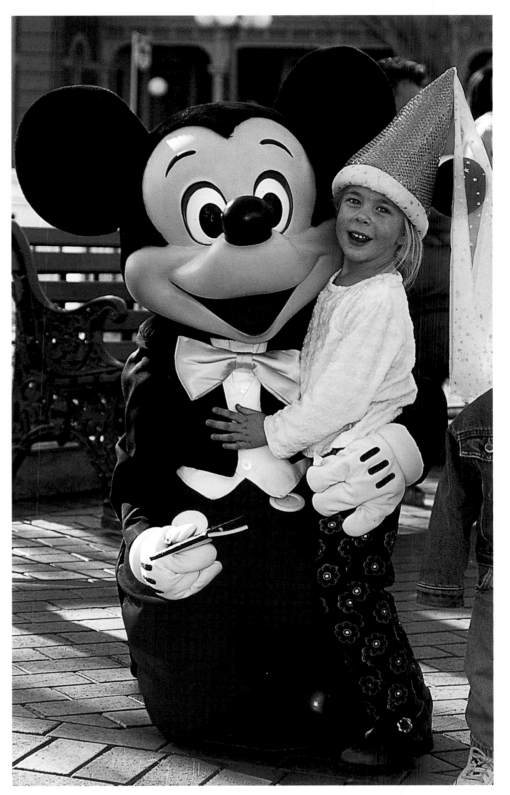

Meet Mickey, big ears to little ears.

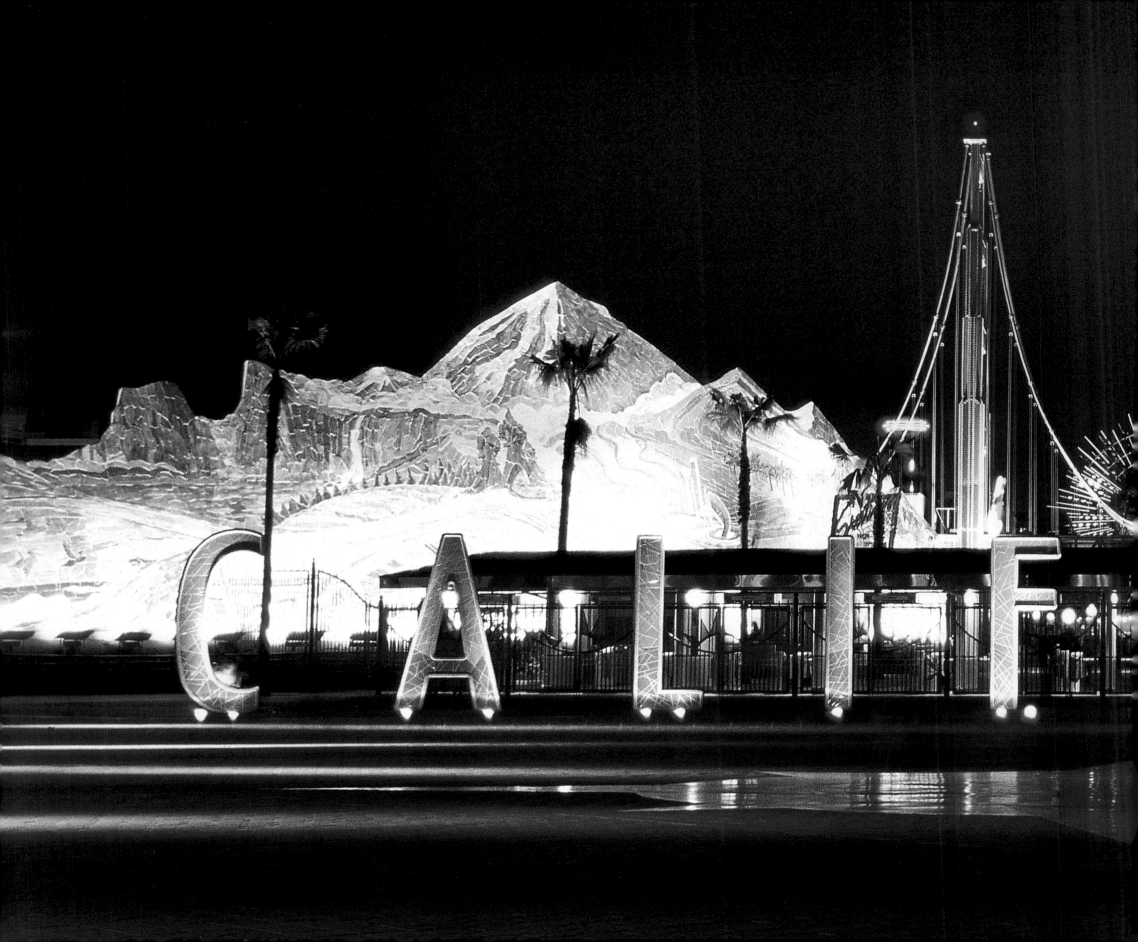

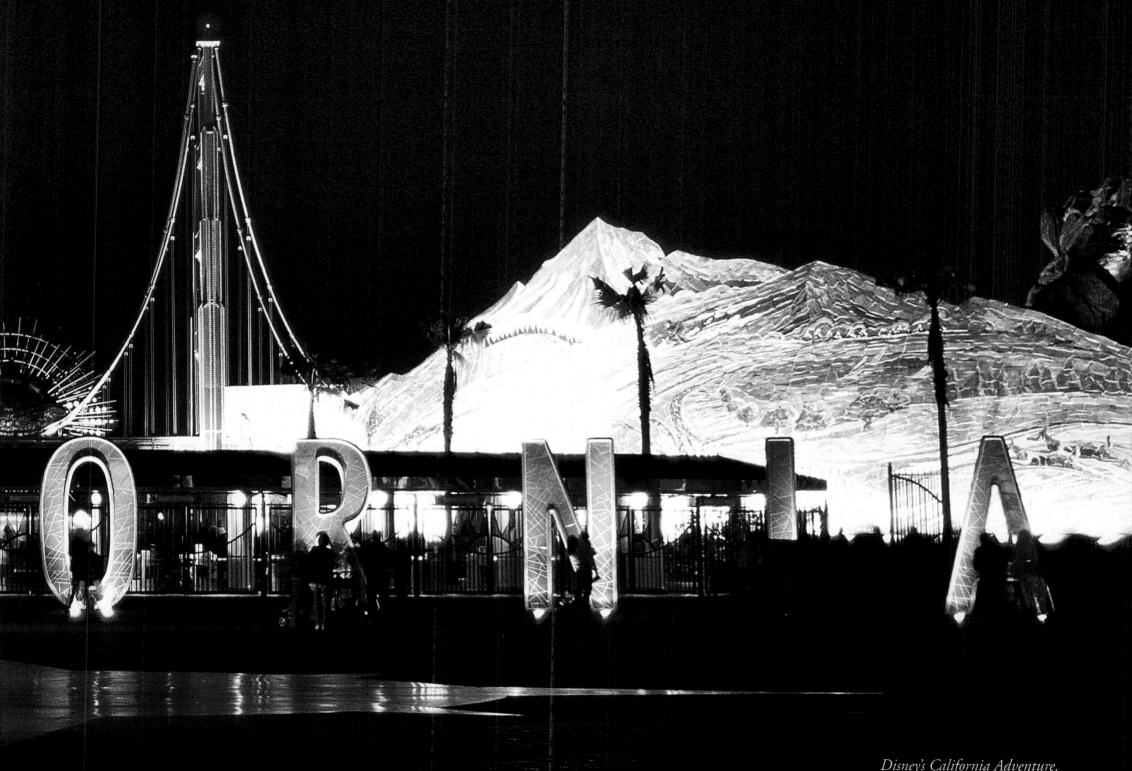

Disney's California Adventure.

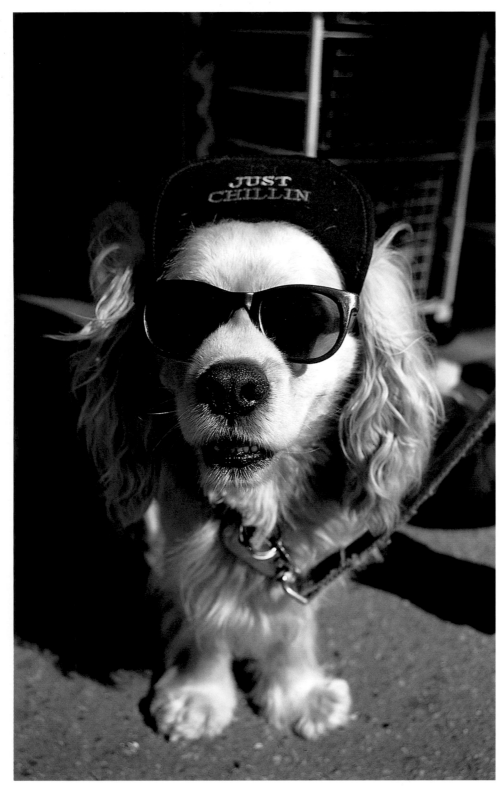

Santa Monica and Venice

"The Zenith City by the Sunset Sea."
—Real estate promotion, 1875.

S un, surf and swimsuits converge in the consummate Southern California beach cities of Santa Monica and Venice. "Bikini babes" Rollerblade down the boardwalk, pumped-up dudes admire themselves on Muscle Beach, and jugglers, magicians, acrobats, psychics and tarot readers add more eye-candy entertainment along Ocean Front Walk. Here is the endless summer.

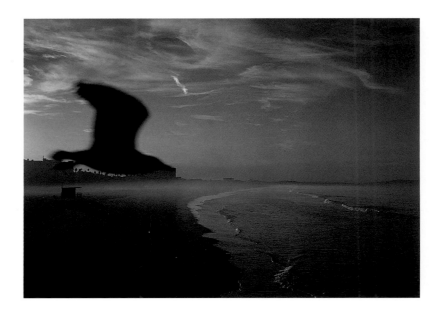

It's a dog's life looking cool.

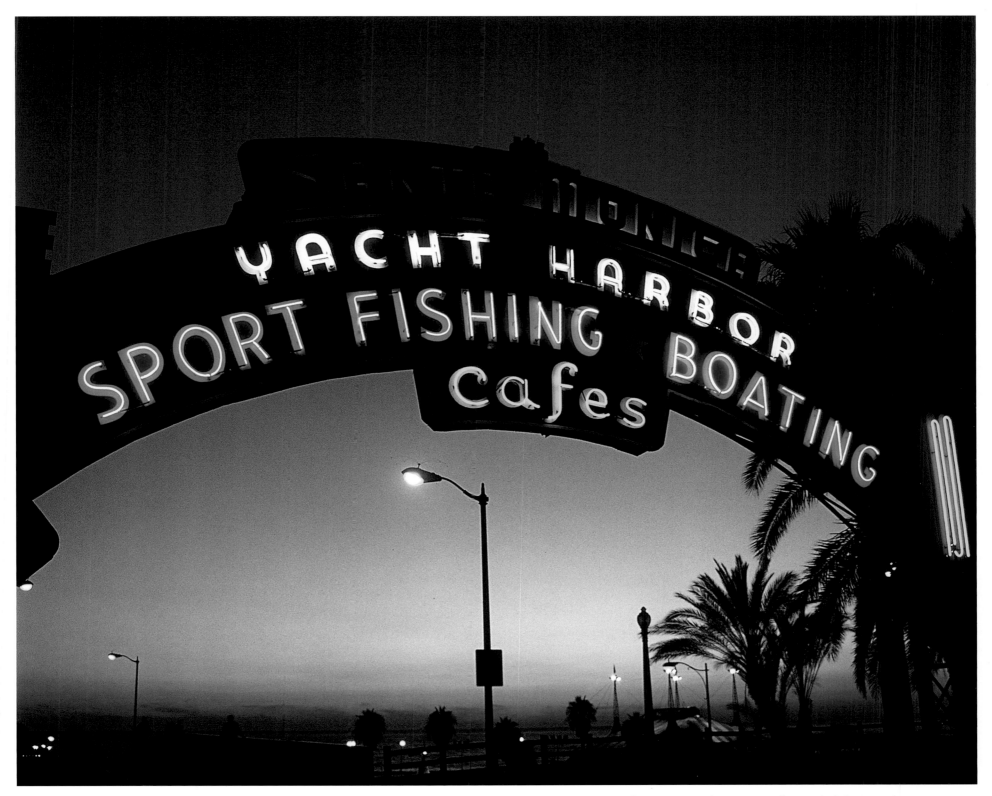

First built in 1874 and rebuilt several times since, Santa Monica Pier is the West Coast's most popular and elaborate amusement pier.

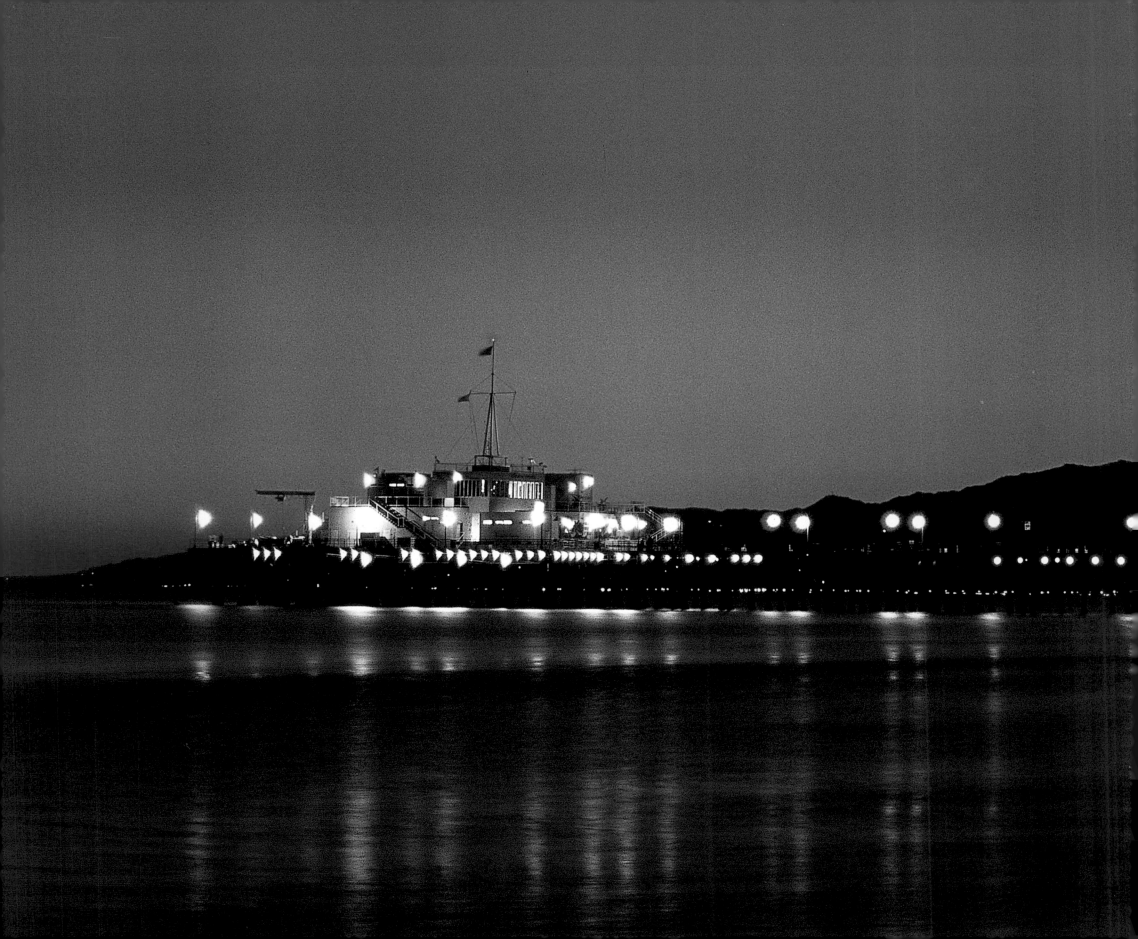

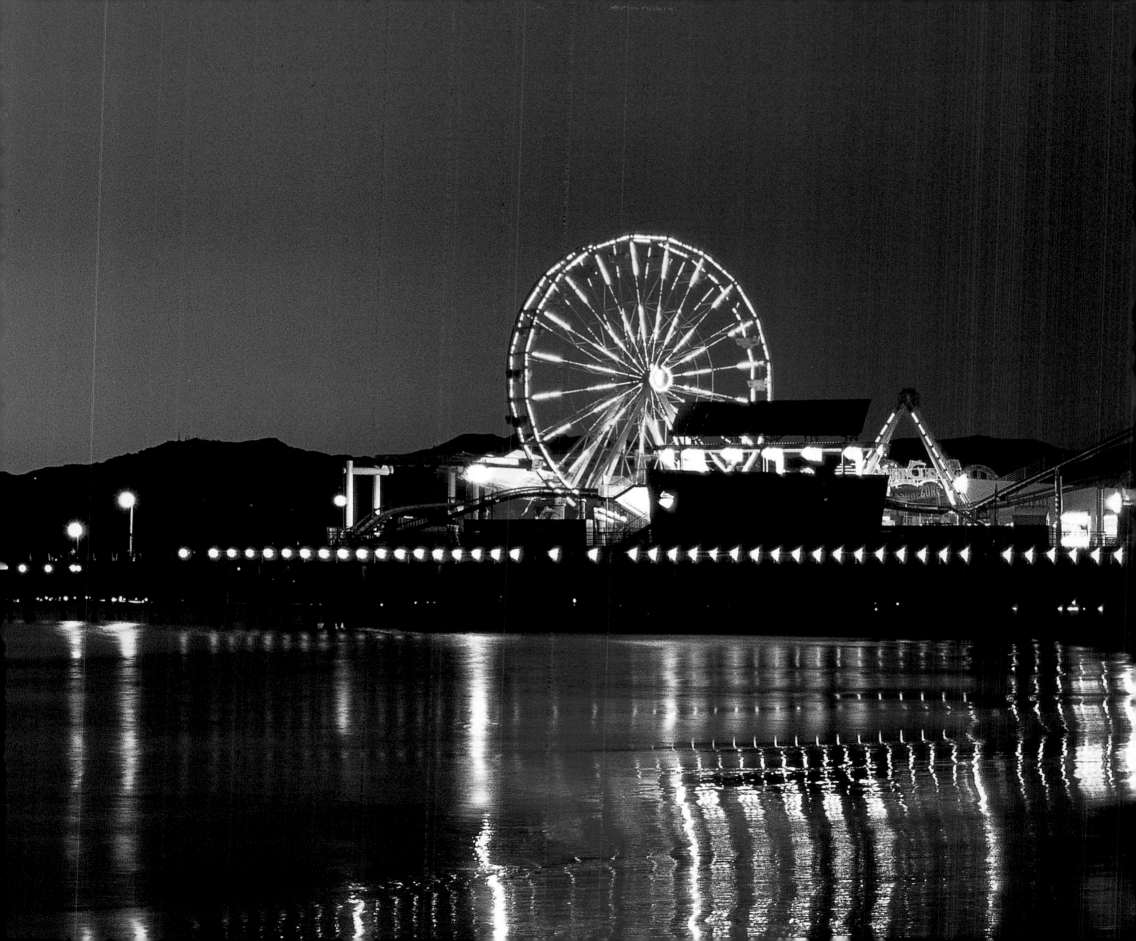

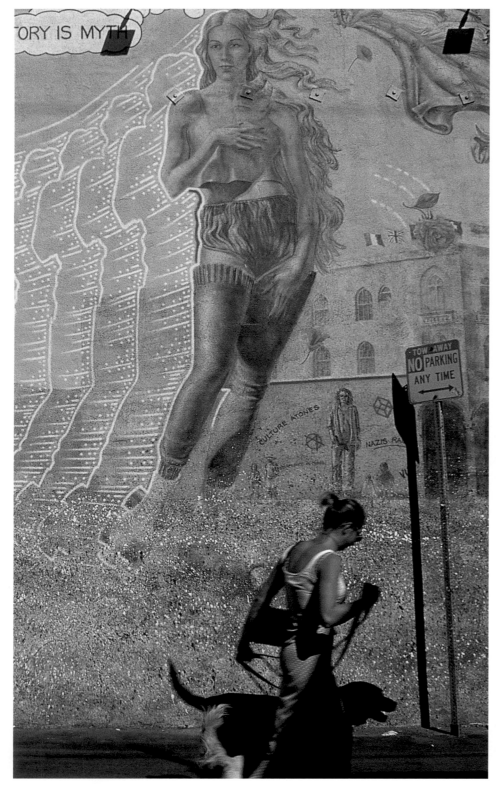

Venus is resurrected as a Rollerblader in Venice.

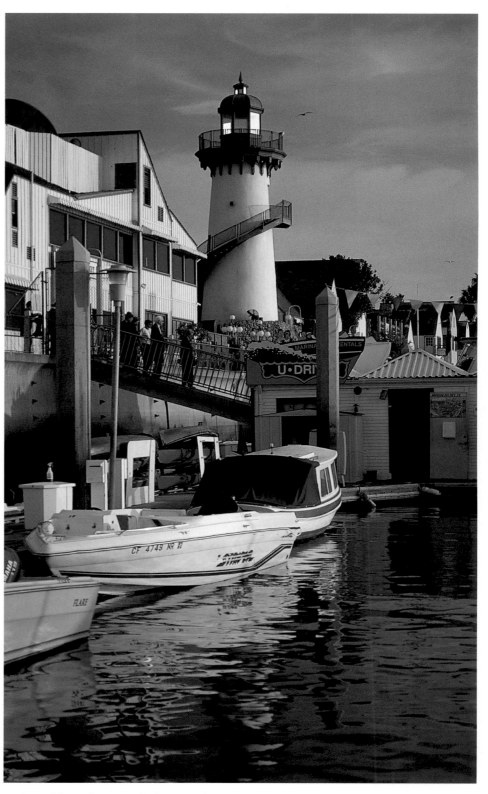

The golden afternoon light at Fisherman's Village in Marina Del Rey.

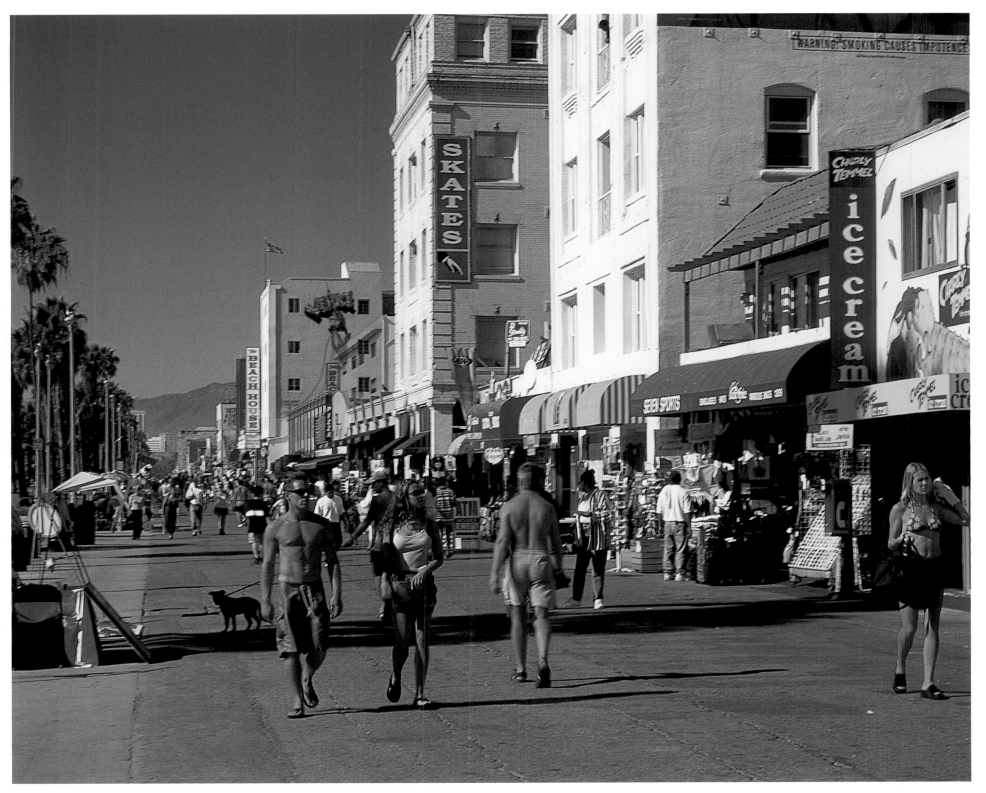

Taking in the sights along Venice's Ocean Front Walk.

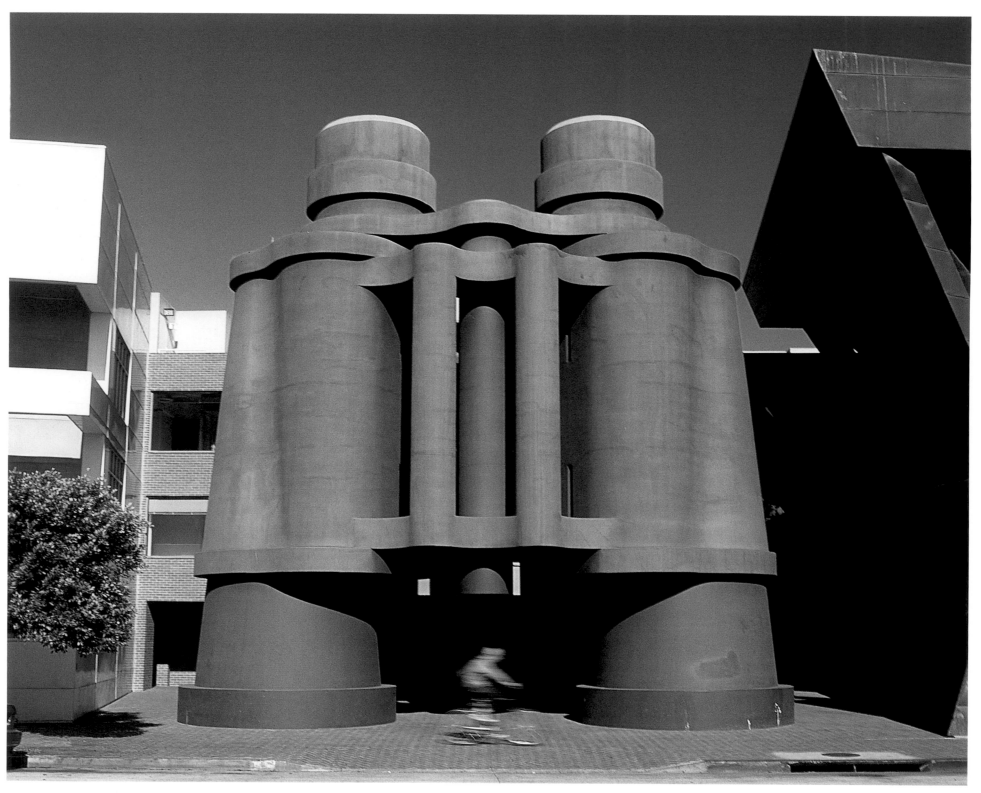

A giant pair of binoculars forms the entrance to TBWA/Chiat/Day, an ad agency in Venice. Inside is a conference room and skylights through the eyepieces.

28

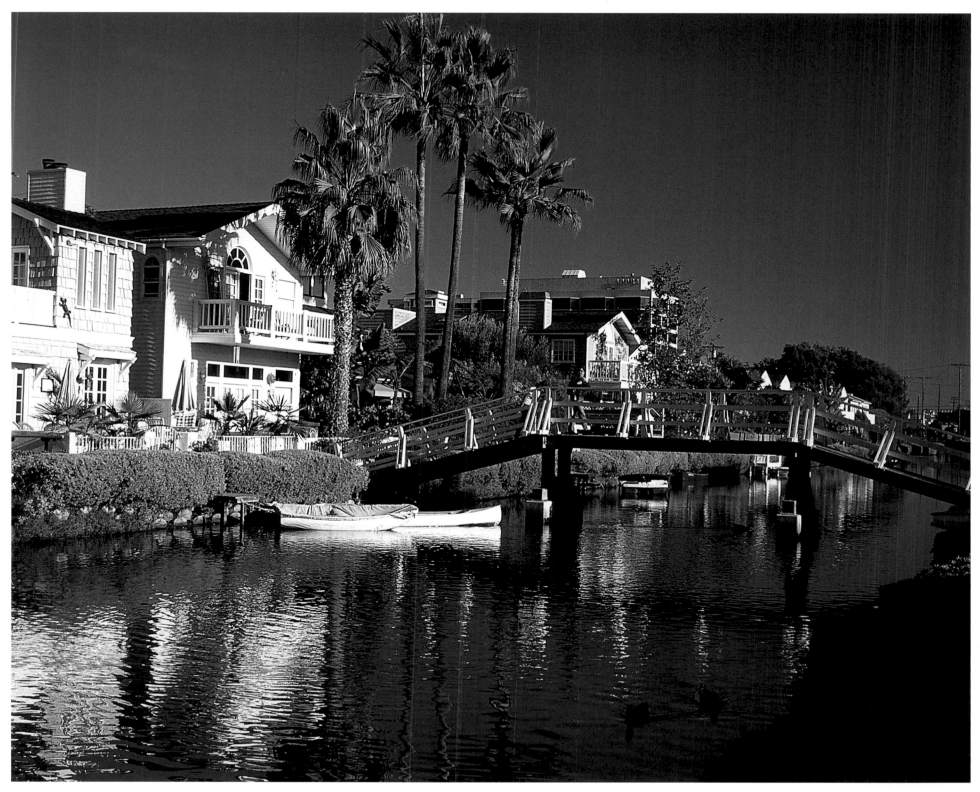

Opened in 1905, "Venice of America" offered a dozen gondoliers imported from Italy, and over 13 miles of canals, some of which remain today.

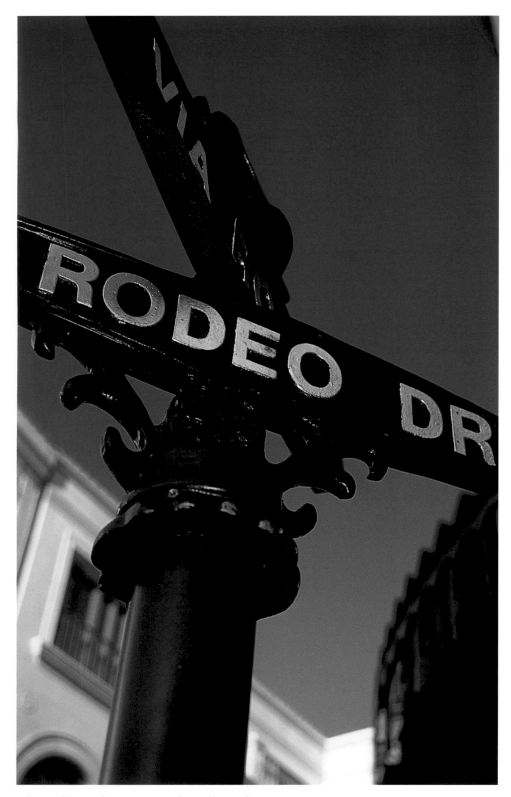

Beverly Hills

"The best-policed six square miles on earth."

Ever since movie power-couple Mary Pickford and Douglas Fairbanks moved here in 1919, Beverly Hills has been home to the rich and famous. Extravagant mansions, palm-lined avenues, and maps to movie star homes are de riguer. Per capita, it is one of the world's wealthiest cities.

No visit to L.A. is complete without a (window-) shopping spree on Rodeo Drive. Prada, Cartier, Chanel, Bulgari, Valentino, Bijan and other shops you can't afford follow one after another. Julia Roberts, in the film *Pretty Woman*, spent "an obscene amount" of Richard Gere's money here before retiring to his suite at the Regent Beverly Wilshire. Well at least we can dream.

Deals are cut and starlets discovered at the Beverly Hills Hotel. The bungalows are almost as famous as the guests, where Marilyn Monroe reputedly trysted with JFK, and Elizabeth Taylor "bungalowed" six of her eight husbands.

Shop till you drop on Beverly Hills' Rodeo Drive.

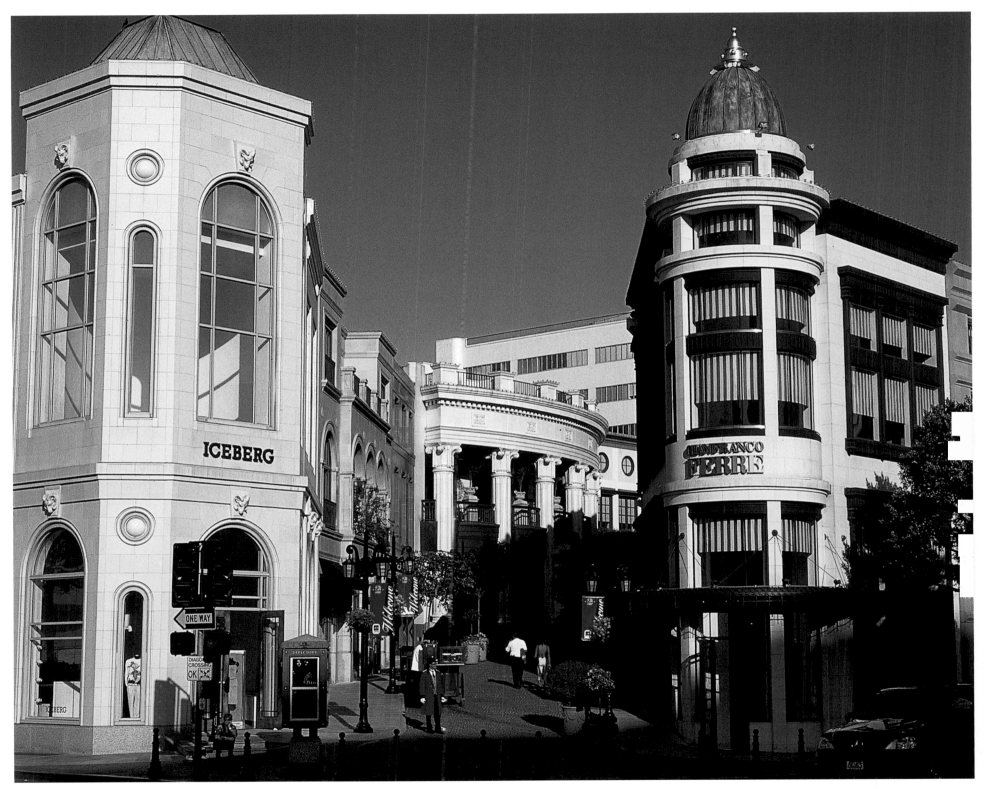

A man in a red coat welcomes shoppers to Two Rodeo Drive.

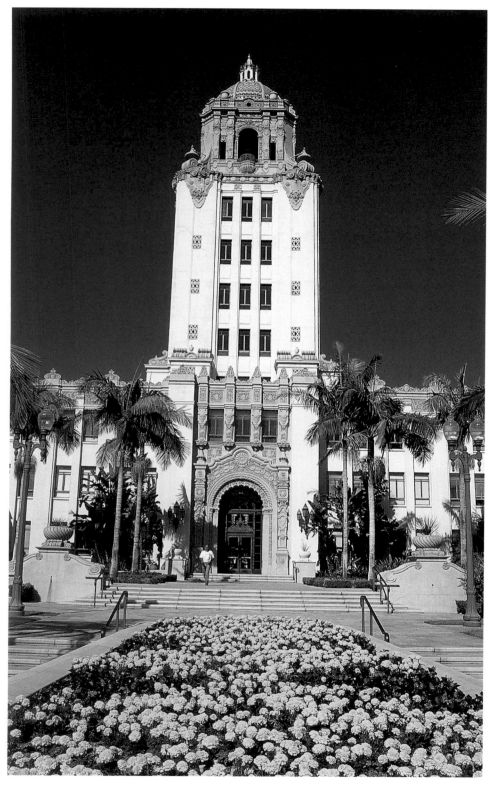

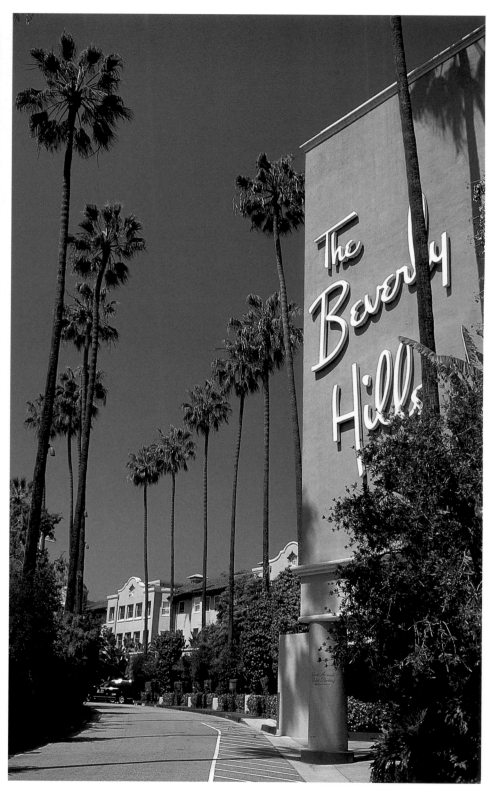

Beverly Hills City Hall.

"Nobody is allowed to fail within a two-mile radius of the Beverly Hills Hotel."
—Gore Vidal

Beverly Hills likes to call itself the "garden spot of the world."

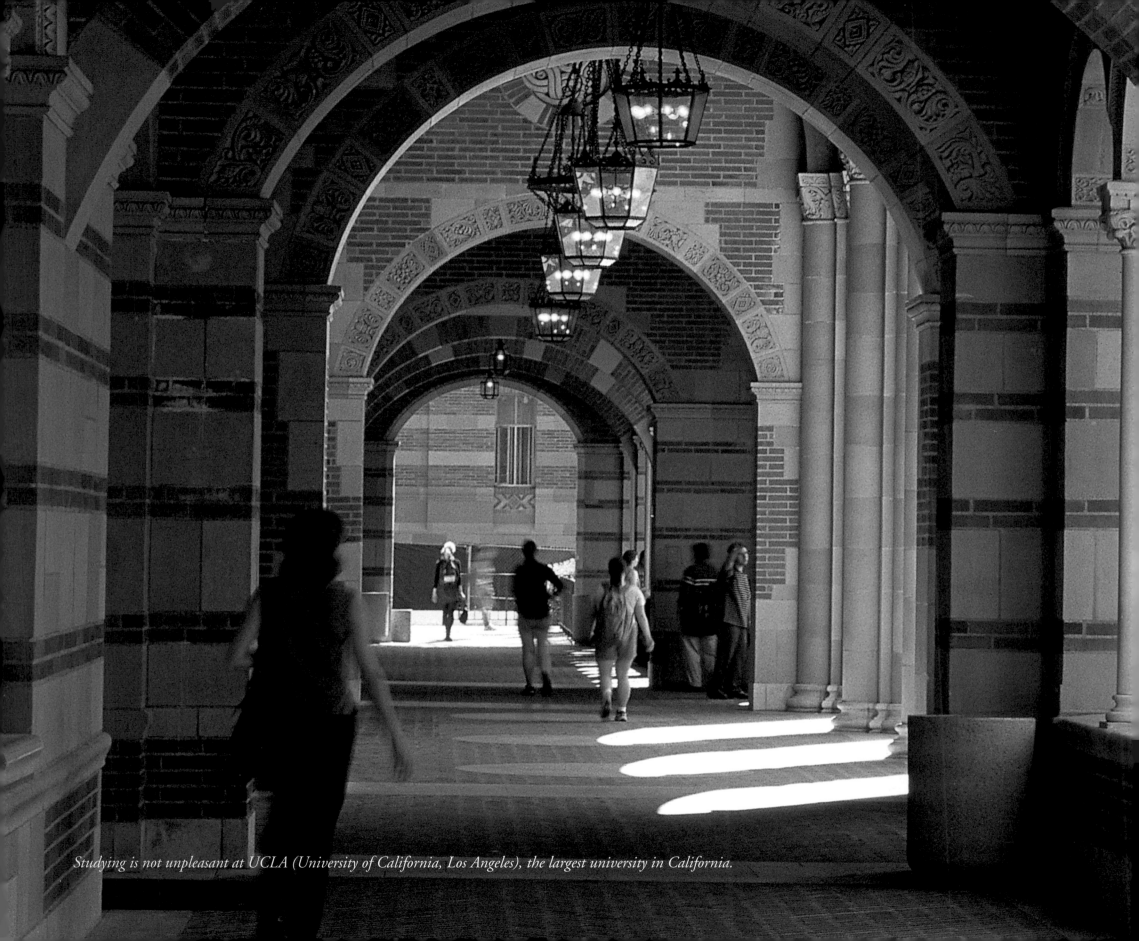

Studying is not unpleasant at UCLA (University of California, Los Angeles), the largest university in California.

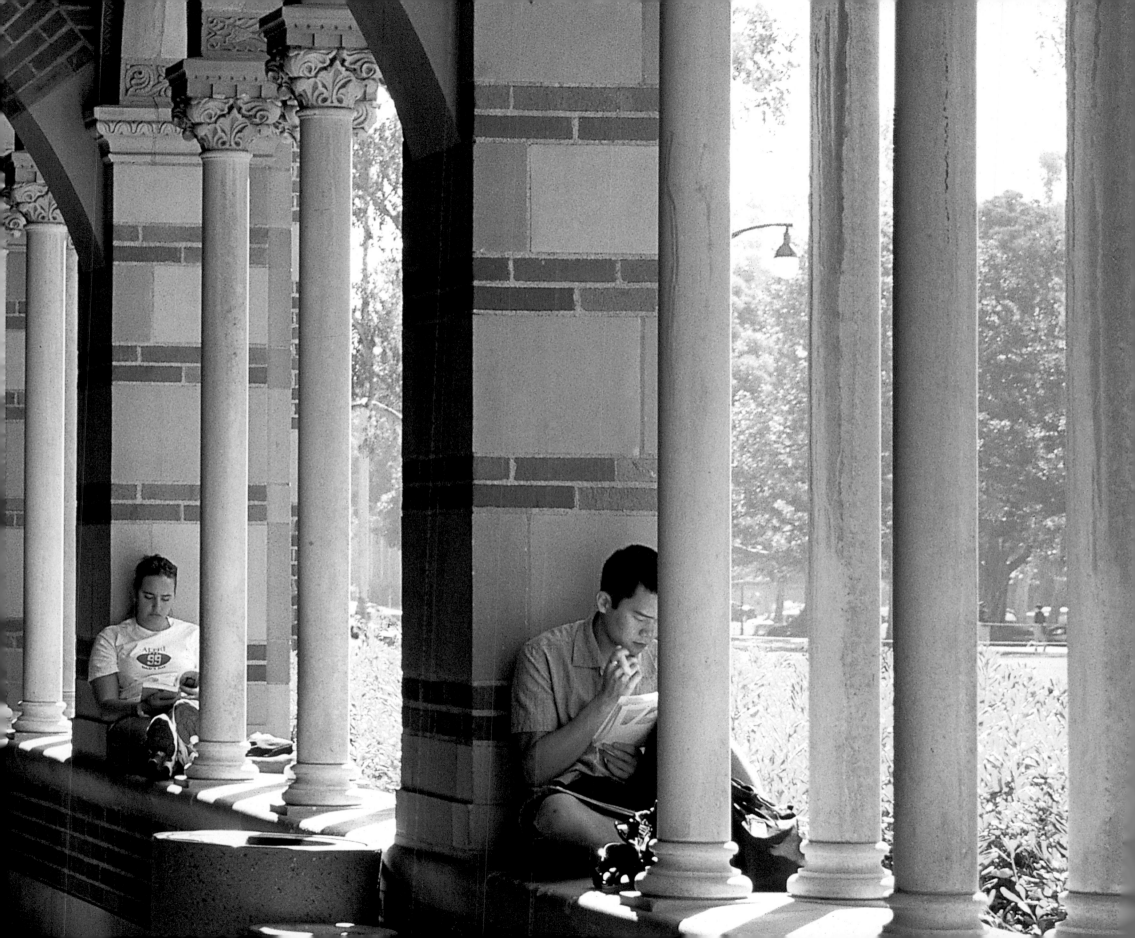

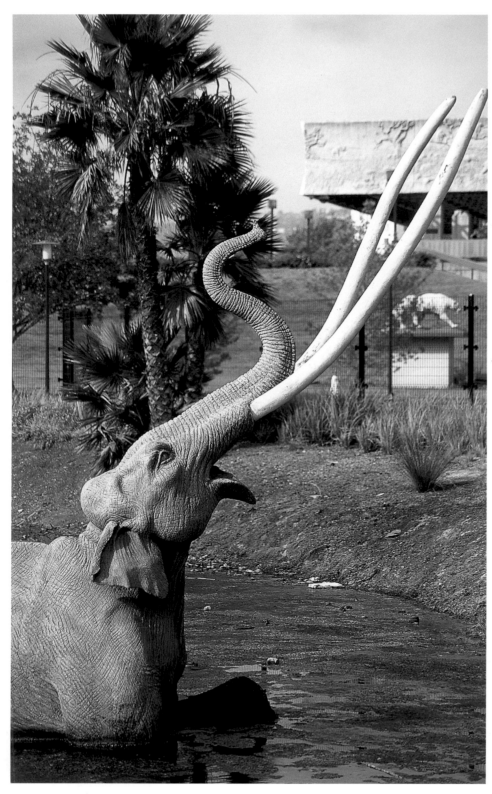

Mammoths and other Ice Agers have been excavated at La Brea Tar Pits.

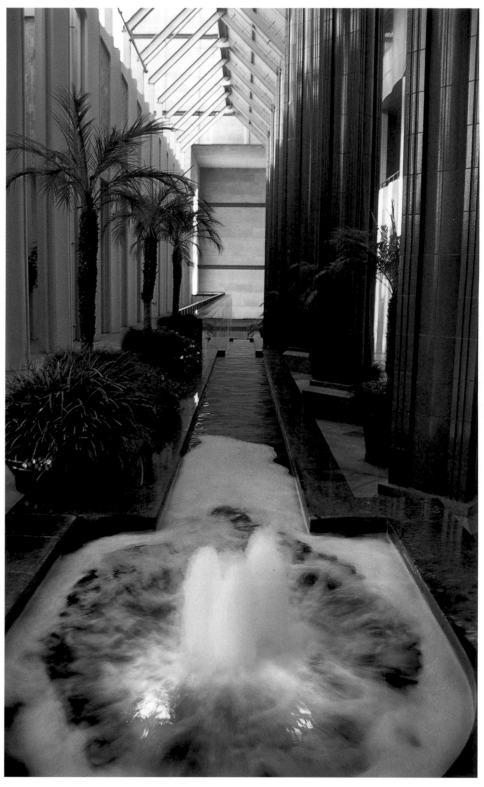

With over 150,000 items, LACMA is one of the country's largest arts museums.

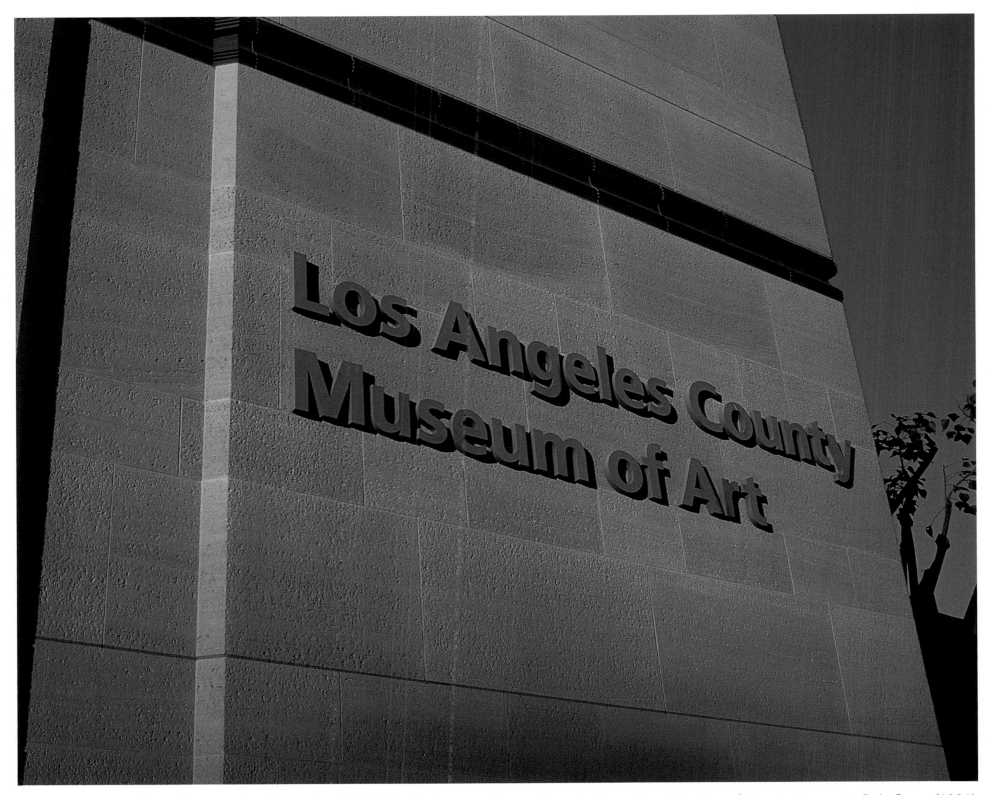

"I was thinking of taking you on a cultural tour of L.A." "That's the first ten minutes, then what?" — Steve Martin and Victoria Tennant in L.A. Story *(1991).*

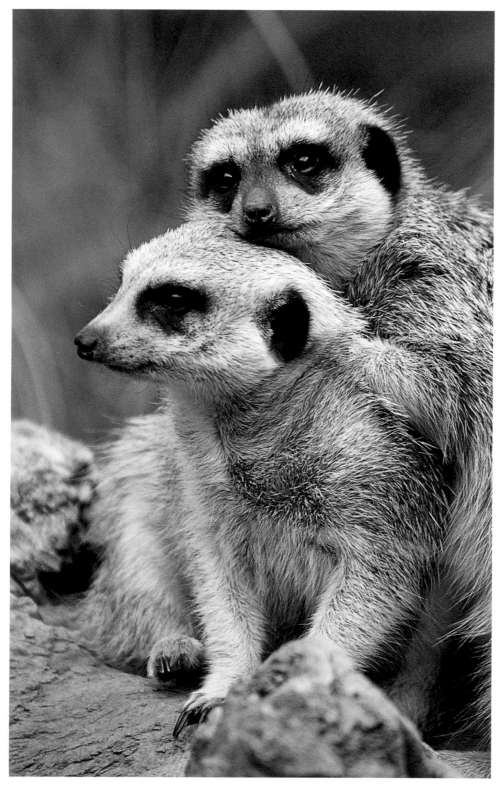

Griffith Park

*"A place of recreation and rest for the masses,
a resort for the rank and file."*
—Griffith J. Griffith, benefactor

Spreading 4,107 acres over unspoilt mountains, Griffith Park is the largest municipal park and urban wilderness area in the nation. From its highest point on Mount Hollywood, 1,652 feet above sea level, are spectacular views of downtown L.A., the San Gabriel Mountains, Pasadena, the Hollywood Sign, Santa Monica and the Pacific Ocean.

In the park's foothills lies Los Angeles Zoo. Over 1,200 animals from around the globe live within the Zoo's 113 acres, including koalas, tigers, gorillas and orangutans.

High on Mount Hollywood lies Griffith Observatory, the largest astronomy museum on the West Coast. Completed in 1935, the observatory is one of the city's finest examples of Art Deco architecture. There are few things finer than watching the sun set over the ocean from the observatory's rooftop terrace.

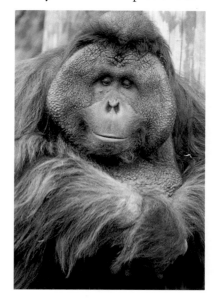

Elsewhere in Griffith Park are golf courses, tennis courts, an antique carousel, a train museum, the Greek Theatre, the Autry Museum of Western Heritage, and 53 miles of hiking trails.

Meerkats stand guard at the Los Angeles Zoo.

38

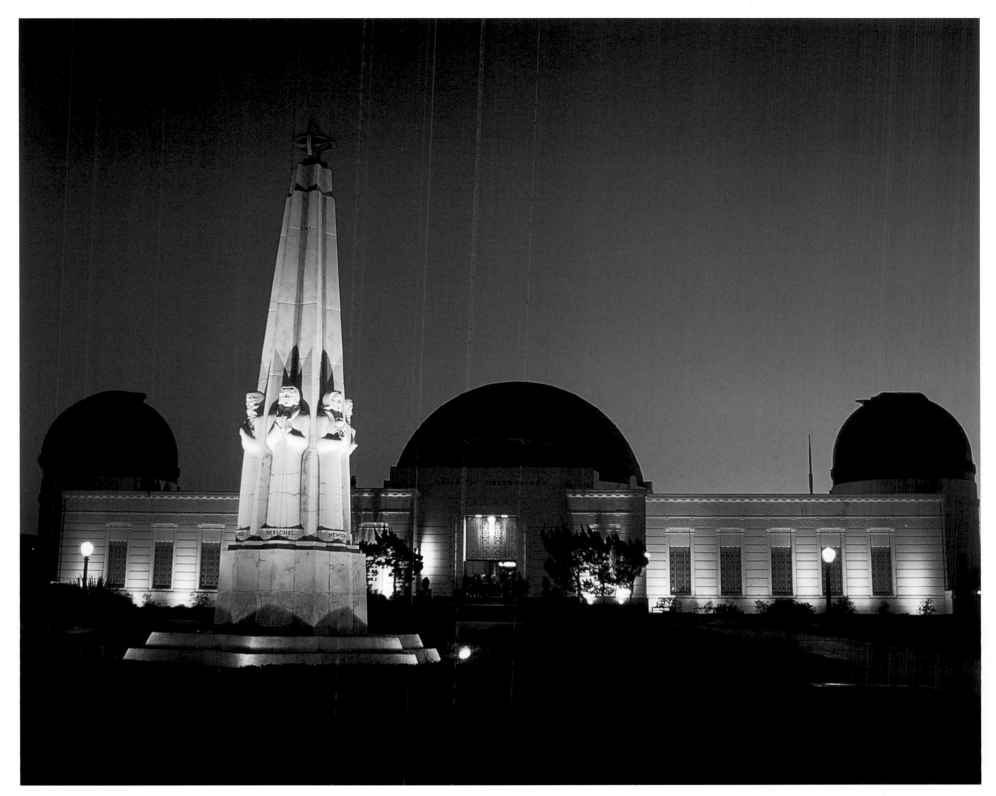

Glimpse the universe from Griffith Observatory. The three domes contain a solar telescope, a planetarium, and a 12-inch refractor telescope.

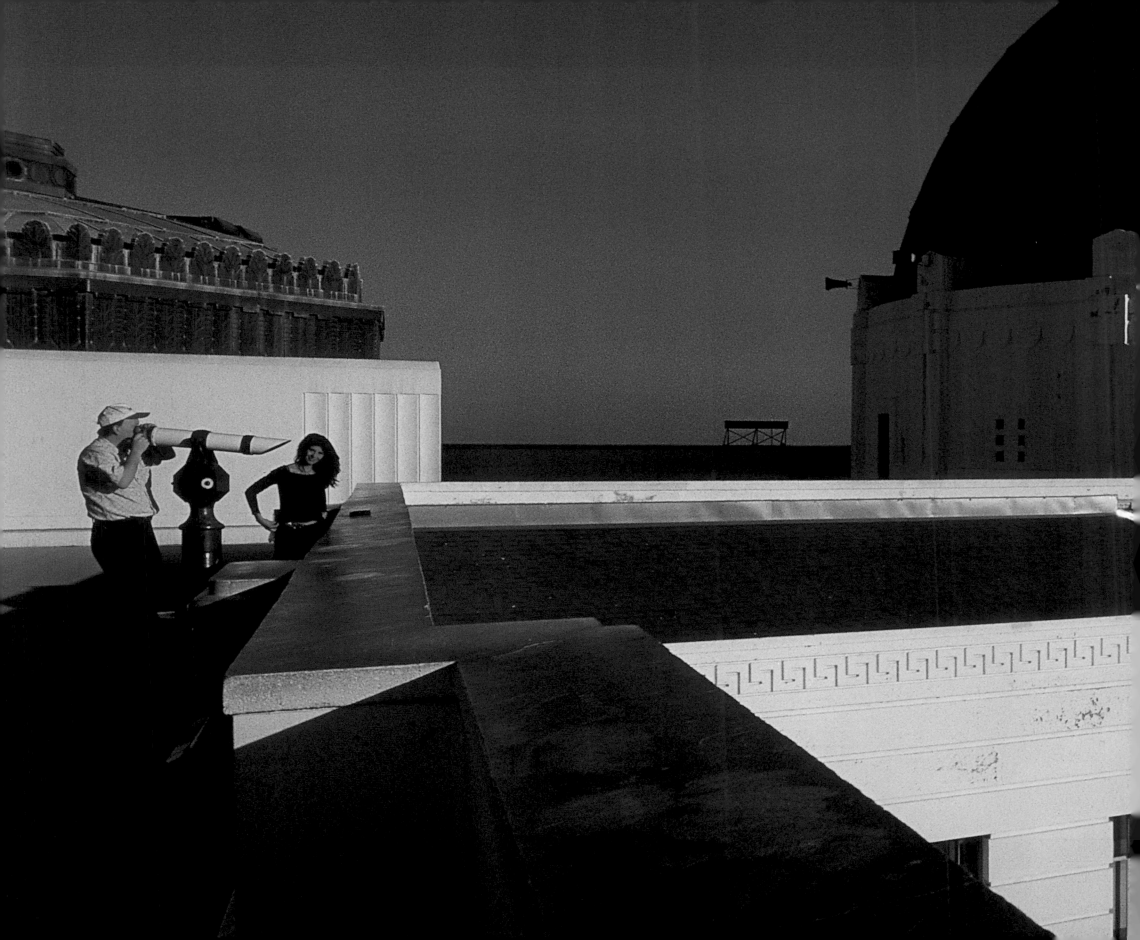

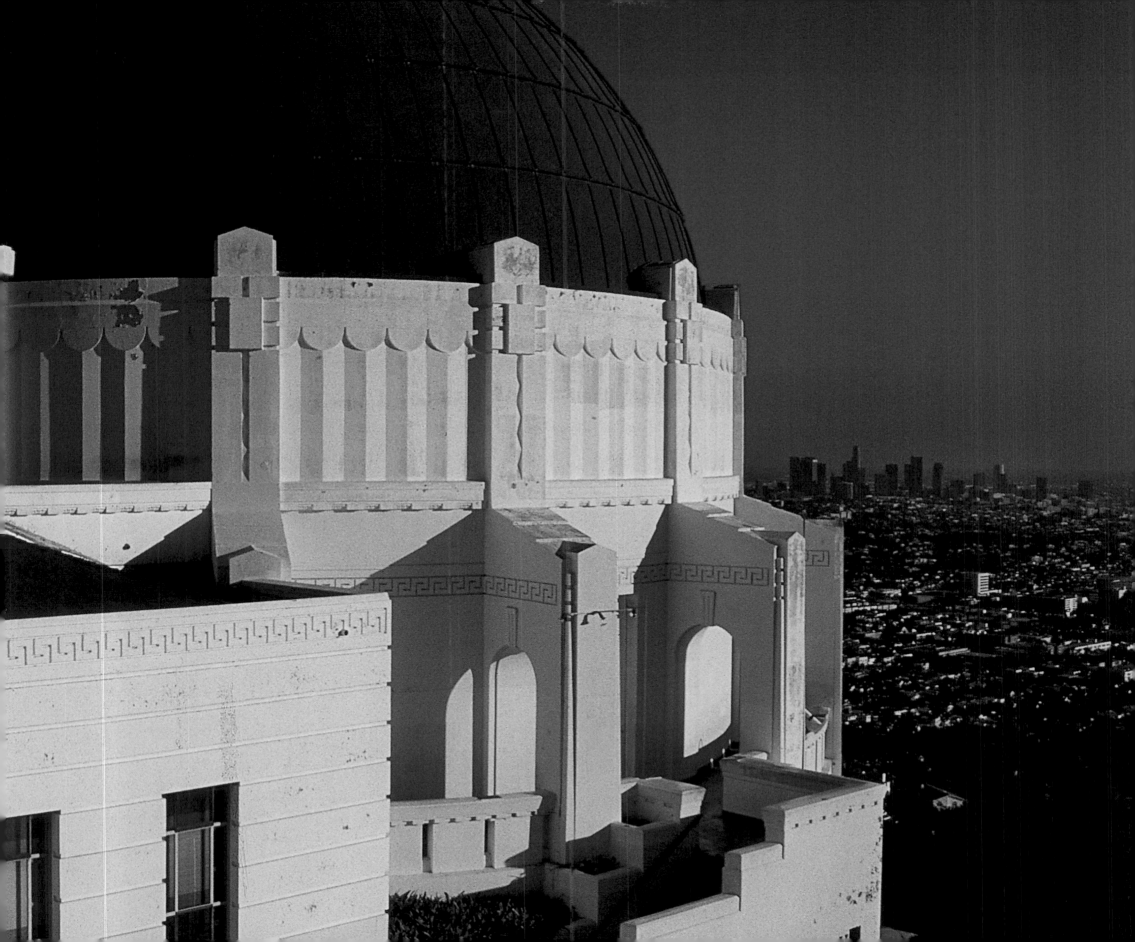

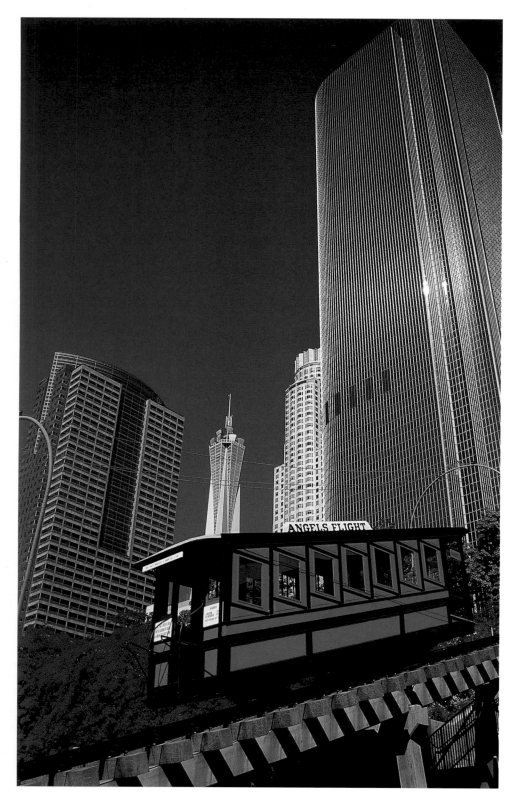

Downtown

"Los Angeles is seventy-two suburbs in search of a city."
—*Dorothy Parker.*

Yes there is a downtown! You'd be forgiven for thinking that L.A. — a city that sprawls over 465 square miles, making it geographically the largest in the nation — has no center. But, nestled between two freeways, and with the San Gabriel Mountains as a backdrop, lies a busy and growing downtown.

Visible from all around is the 73-story Library Tower, the tallest building on the West Coast. At its base, Bunker Hill Steps rises like Rome's Spanish Steps, leading past the 444 Building, more recognizable from its role in TV's *L.A. Law*.

Los Angeles was founded in 1781 by settlers from Mexico, and buildings dating from 1818 still remain near the original birthplace, at El Pueblo Historic Park. The West's first movie was shot downtown in 1907. Despite no significant water supply or natural harbor, L.A. has grown to become the country's second most populous city.

Dating from 1901, Angels Flight is called "the shortest railway in the world."

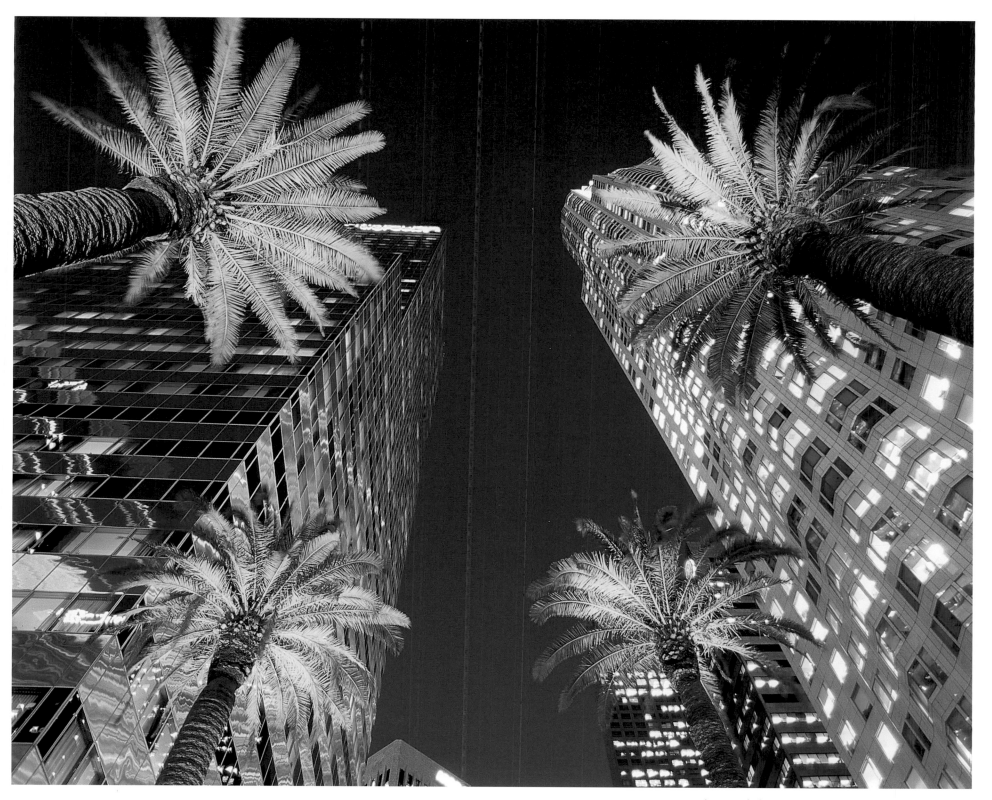

Palms and skyscrapers tower over downtown L.A.

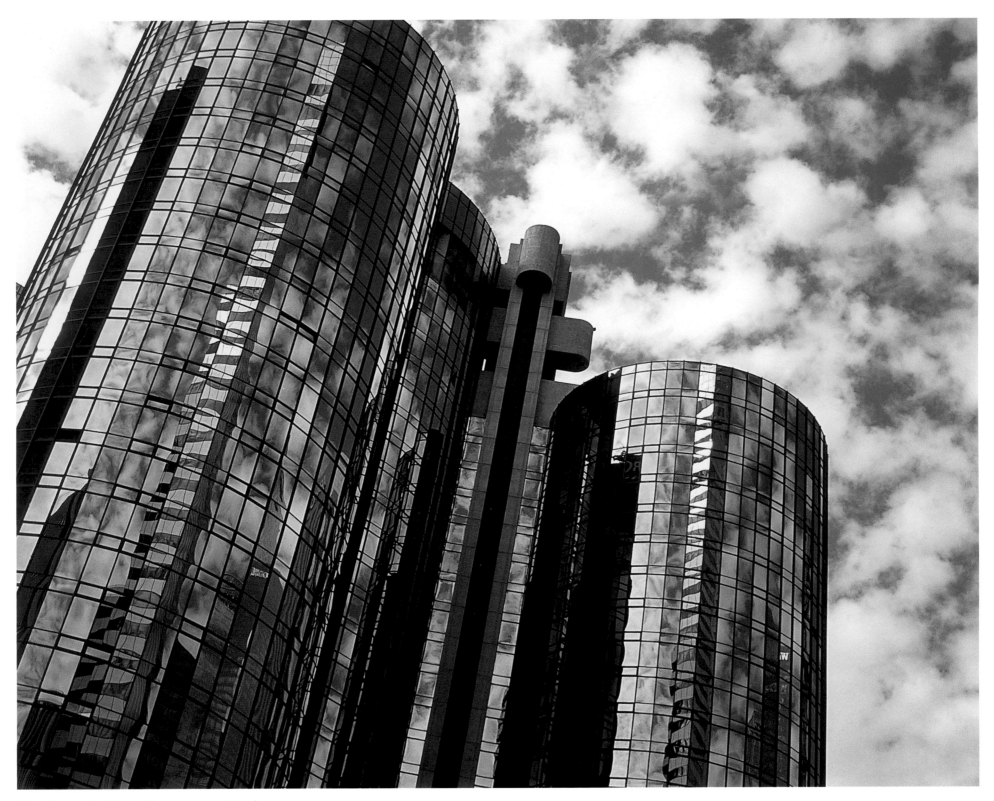

The futuristic Westin Bonaventure Hotel.

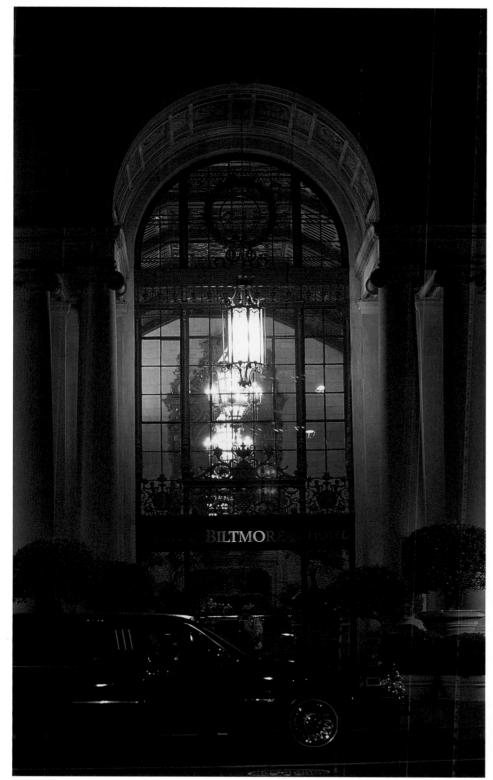

The lavish Biltmore Hotel (1923) hosted the Academy Awards® in the 1930s.

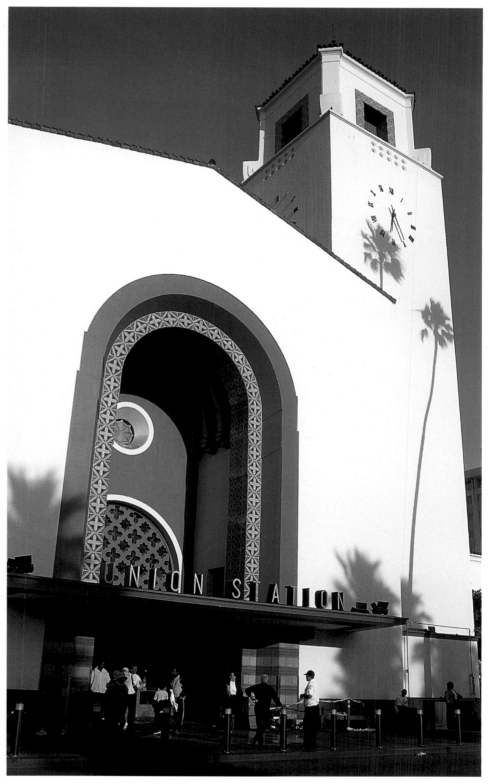

Union Station (1939) was the last of the great American railroad stations.

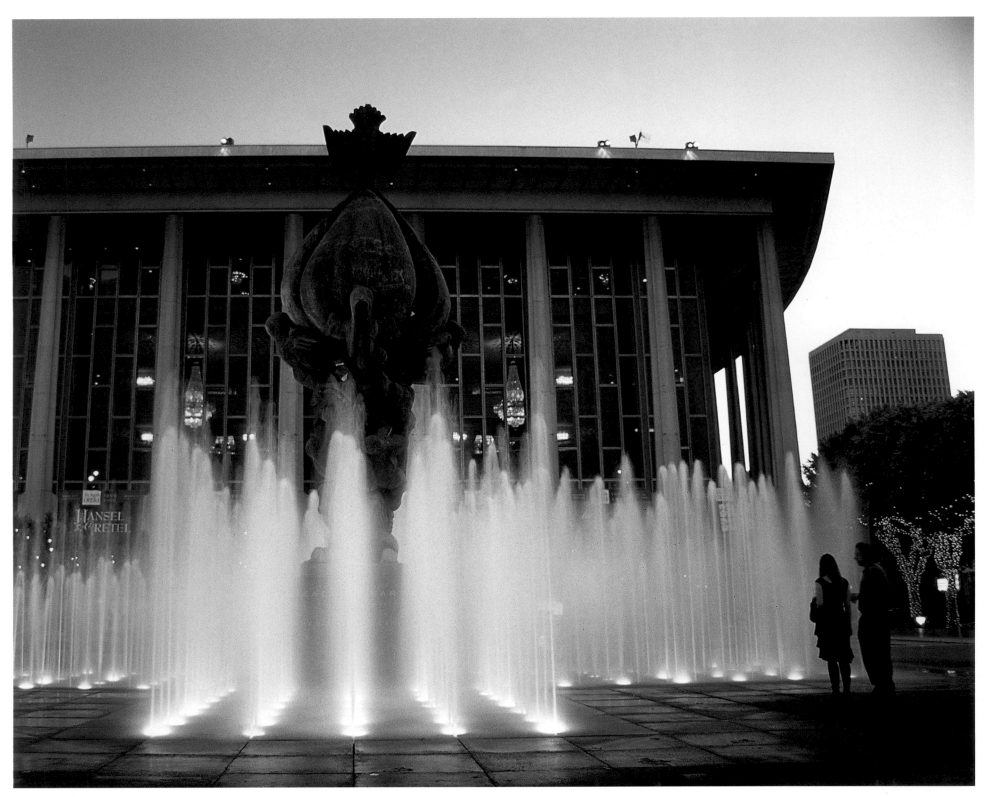

The Dorothy Chandler Pavilion (1964) is home to the Los Angeles Opera and Los Angeles Philharmonic.

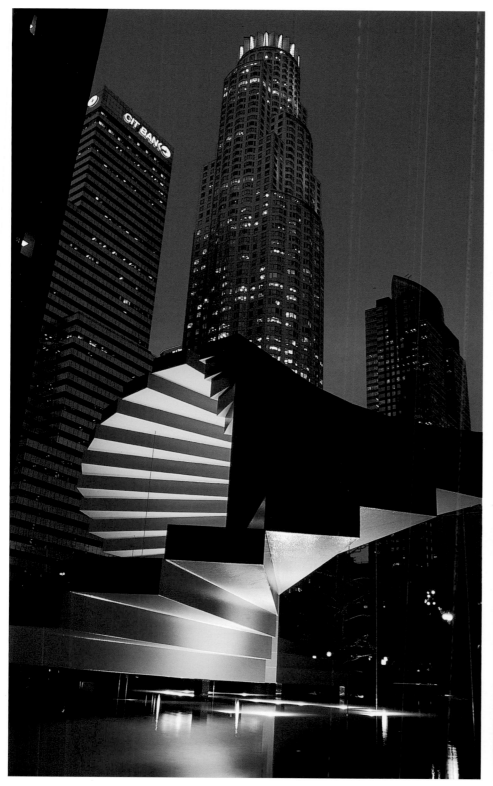

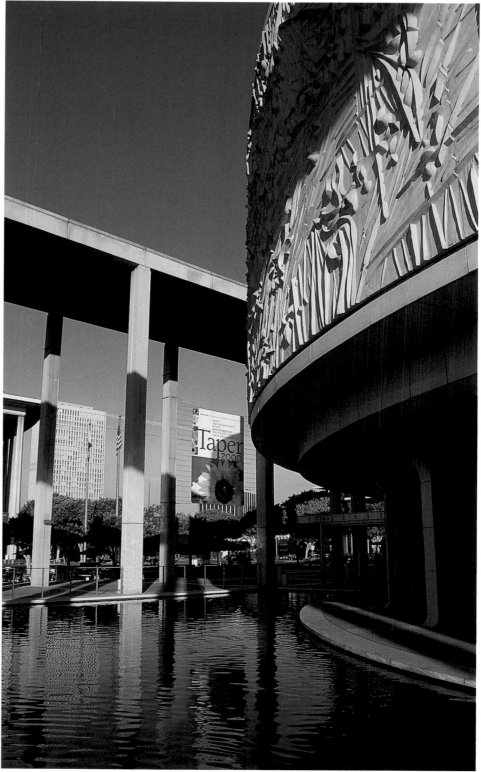

Modern sculptures grace L.A.'s downtown. *Renowned for its new plays, the Mark Taper Forum has won 18 Tony Awards®.*

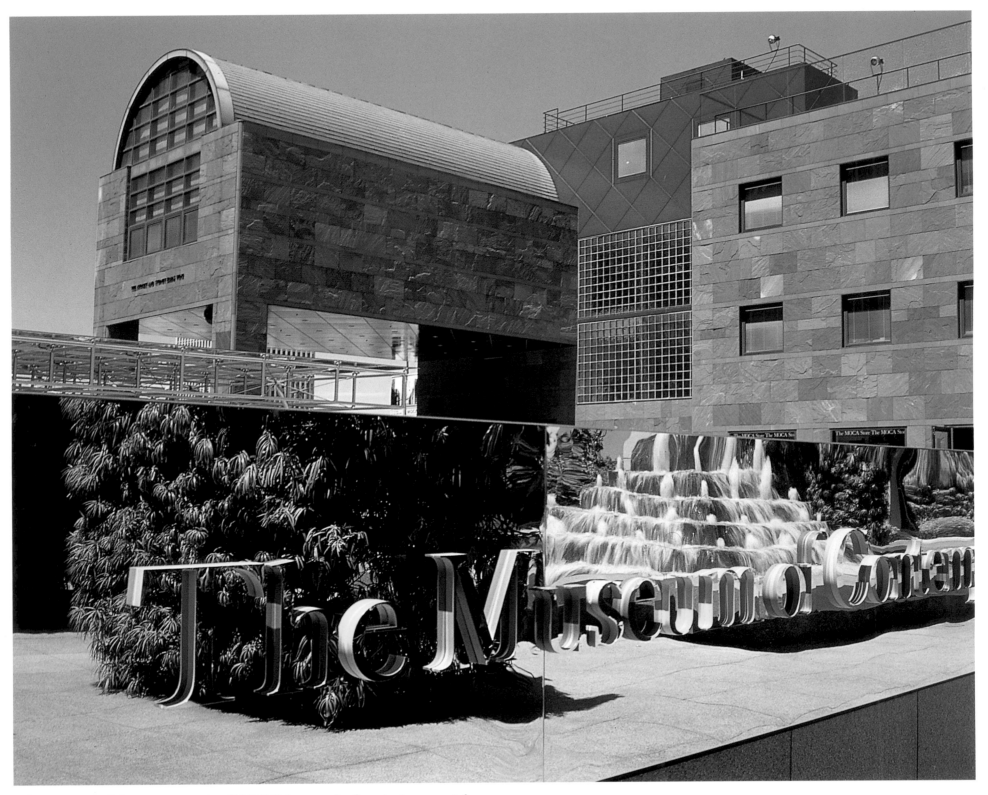

The Museum of Contemporary Art (MOCA) is a work of art in its own right.

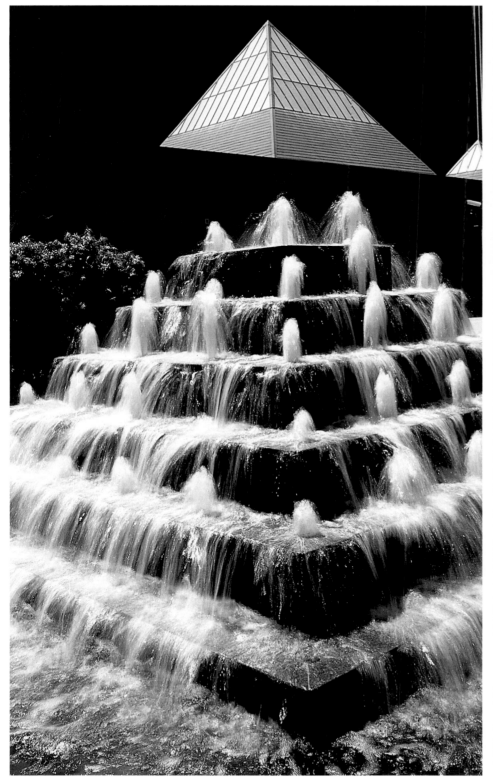

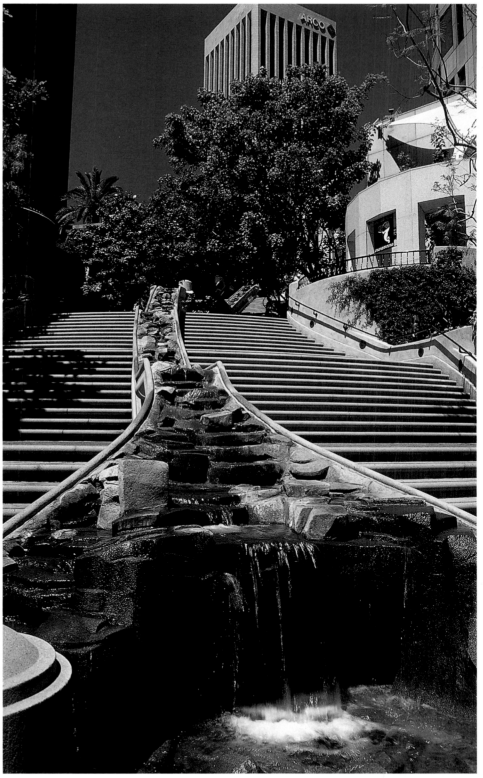

Fountains at MOCA (left) and Bunker Hill Steps.

49

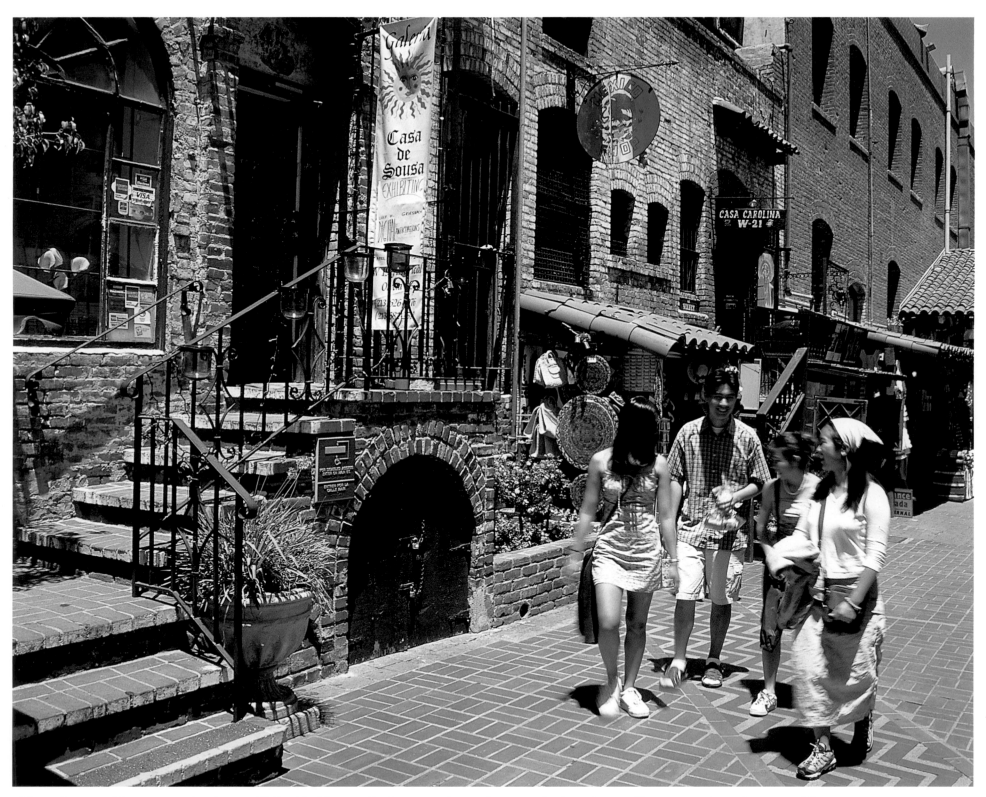

Olvera Street, a Mexican marketplace in El Pueblo Historic Park, is popular with visitors looking for tortillas, margaritas, piñatas and fiestas.

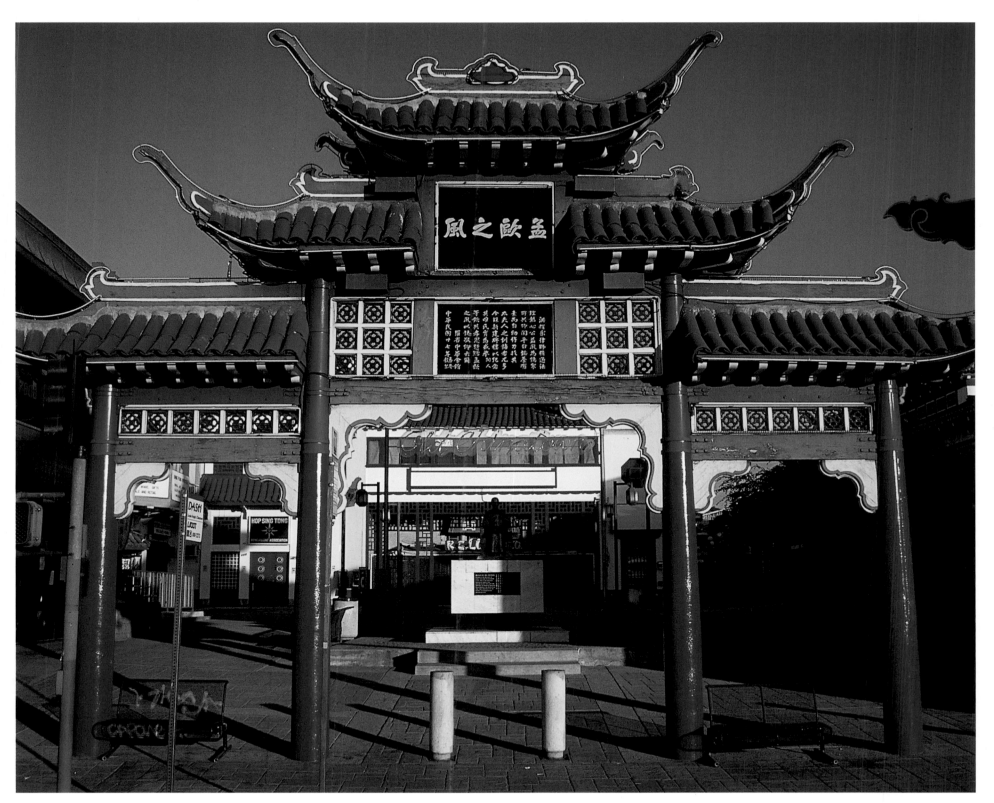

Chinatown is a spiritual and cultural center for many Chinese, since their arrival in the 1870s.

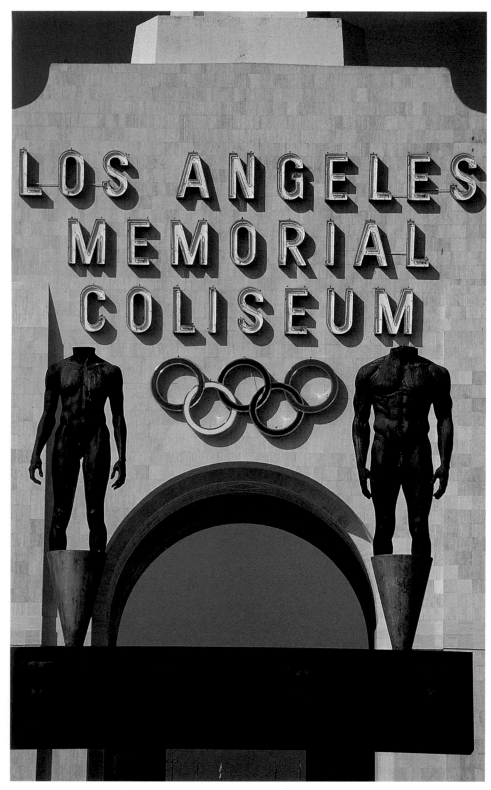

The Coliseum hosted the '32 and '84 Summer Olympics and two Super Bowls.

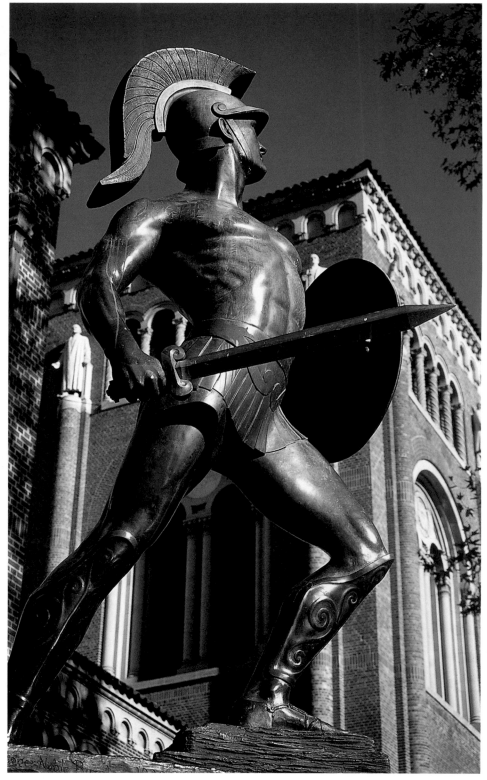

Tommy Trojan guards USC, one of the West's oldest private universities.

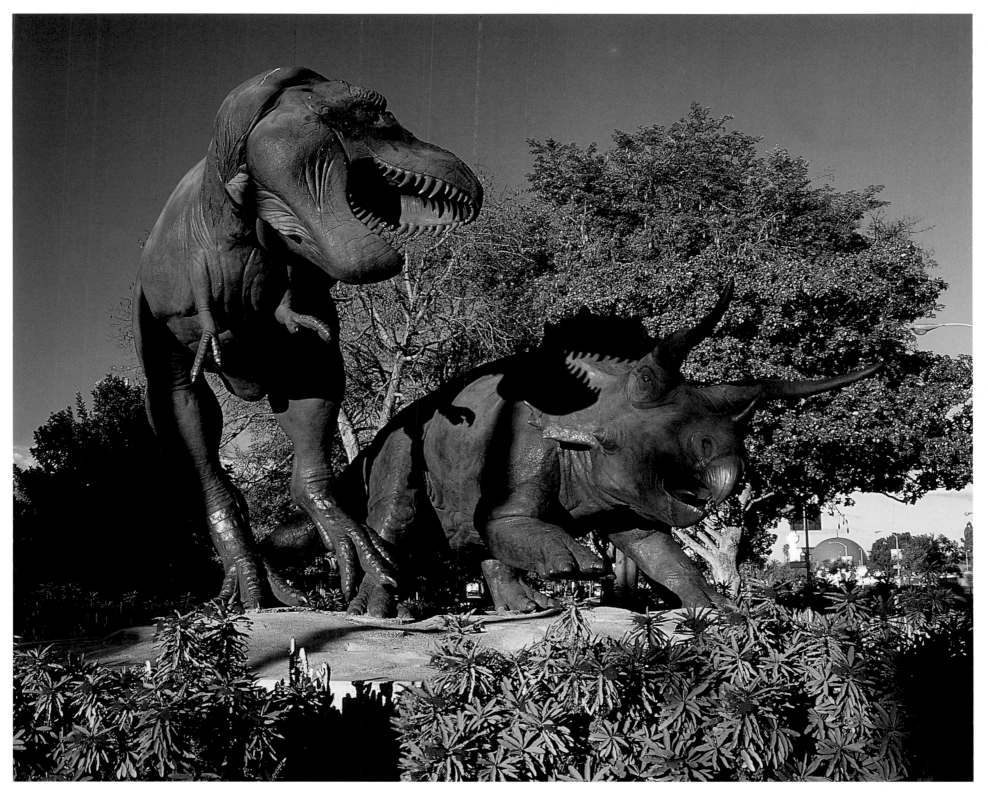

Opened in 1913, the Natural History Museum of Los Angeles is one of the largest, most-visited museums in California.

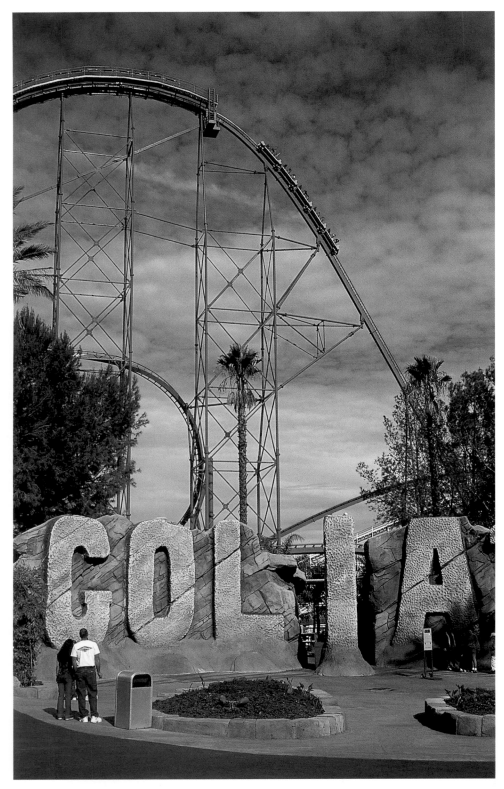

Dropping out of the sky on Goliath.

Six Flags
Magic Mountain

"The Xtreme Park"

Hold on to your hats! This thrill-seeker's paradise has more roller coasters (15) than any other theme park. At the top of the list is Goliath, the West Coast's tallest and fastest roller coaster. Brave (or foolish) riders plunge 255 feet into a pitch-black tunnel, then exit at 85 mph. The views are terrific — if you can bear to keep your eyes open.

You'll believe a man can fly on Superman The Escape. Riders accelerate from 0 to 100 mph in 7 seconds before shooting straight up a 41-story tower. Over 6 seconds of weightlessness are experienced as riders begin the terrifying descent – backwards.

If that's not enough, try Riddler's Revenge, the world's tallest and fastest stand-up roller coaster which spins head-over-heels six times; or Colossus, the West's tallest wooden roller coaster; or Viper, the world's largest looping roller coaster. After all that, even driving in L.A. will feel relaxing!

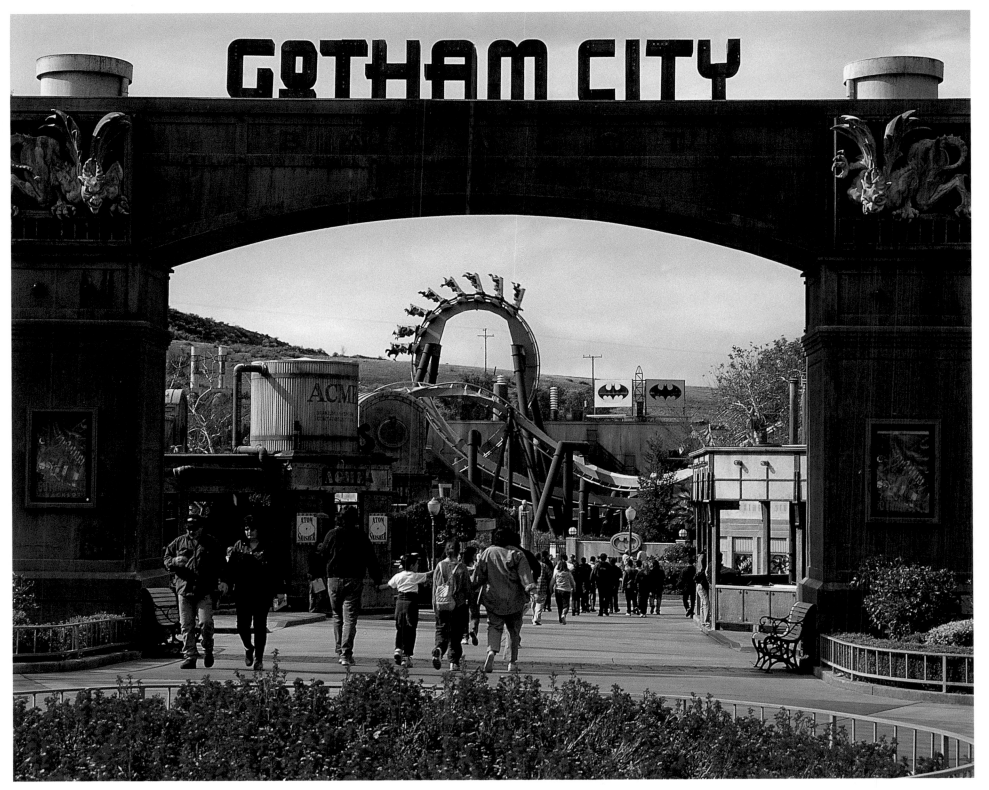

Fight fear itself on Batman The Ride, in Magic Mountain's Gotham City Backlot.

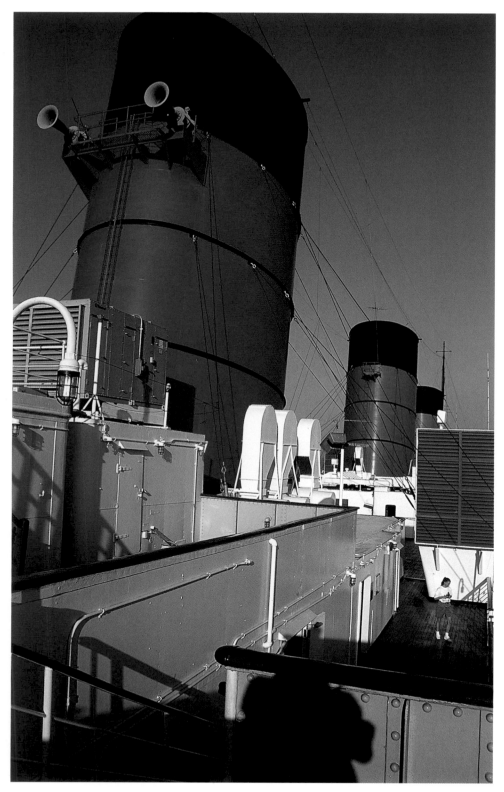

Board the ship favored by Fred Astaire, Greta Garbo, and the Duchess of Windsor.

The Queen Mary

"The stateliest ship afloat."
—King George V, 1934.

Longer than the Titanic, the Queen Mary is the world's largest luxury liner, and one of history's most famous passenger ships.

Launched from Scotland in 1934, she soon captured the prized Blue Riband by crossing the Atlantic in record time. During WWII, the Queen Mary and her sister ship the Queen Elizabeth carried over a million troops to Europe and were credited by Winston Churchill for shortening the war by a year. Hitler was so incensed he promised the Iron Cross and $250,000 to any U-boat captain who could sink one of the great liners, but none could. Sailing a zig-zag course to avoid the submarines, the Queen Mary carried up to 16,000 troops at time —almost an entire army division —and lifeboats for just 145.

After crossing the Atlantic more than 1,000 times, the Queen Mary was bought by the city of Long Beach in 1967 and is now a 365-room hotel and popular attraction. She became a movie star in the 1972 film, *The Poseidon Adventure.*

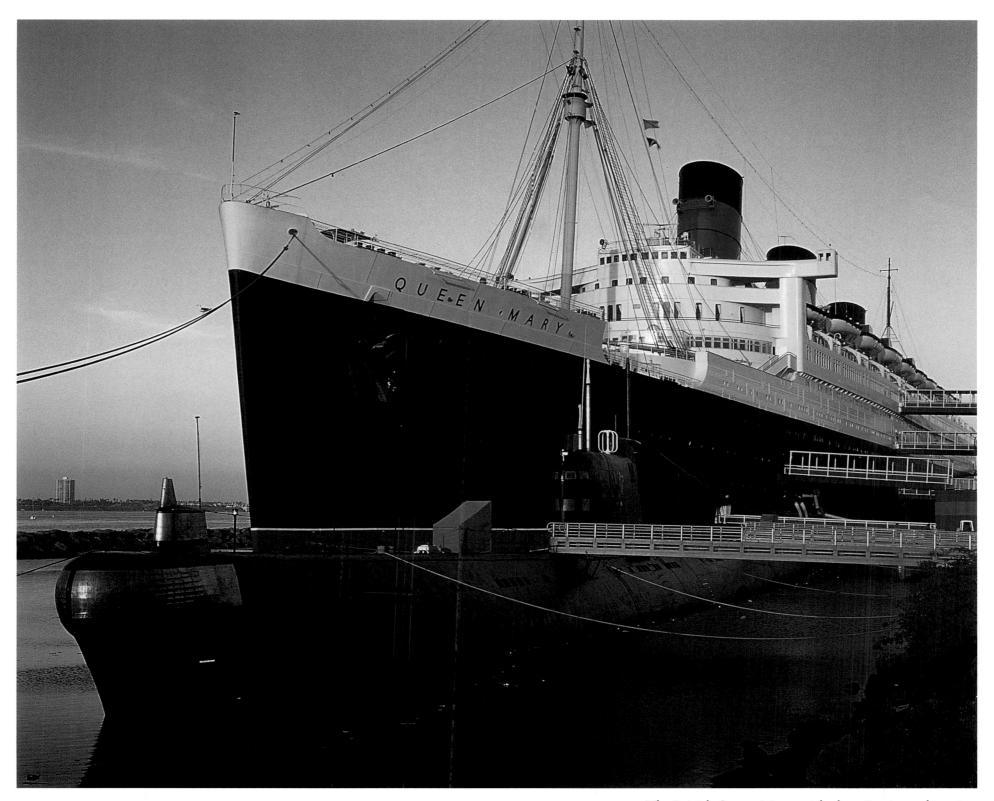

The British Queen Mary resides by a Russian submarine.

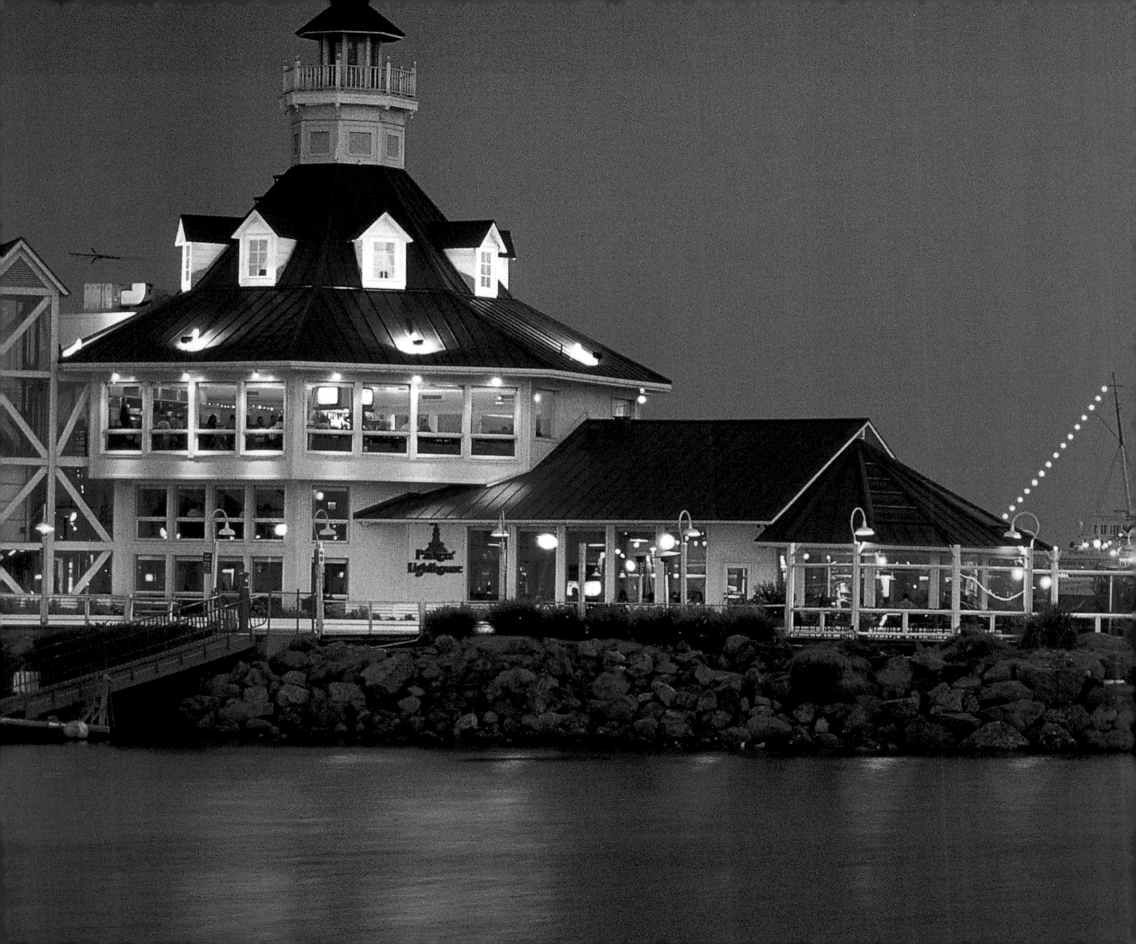

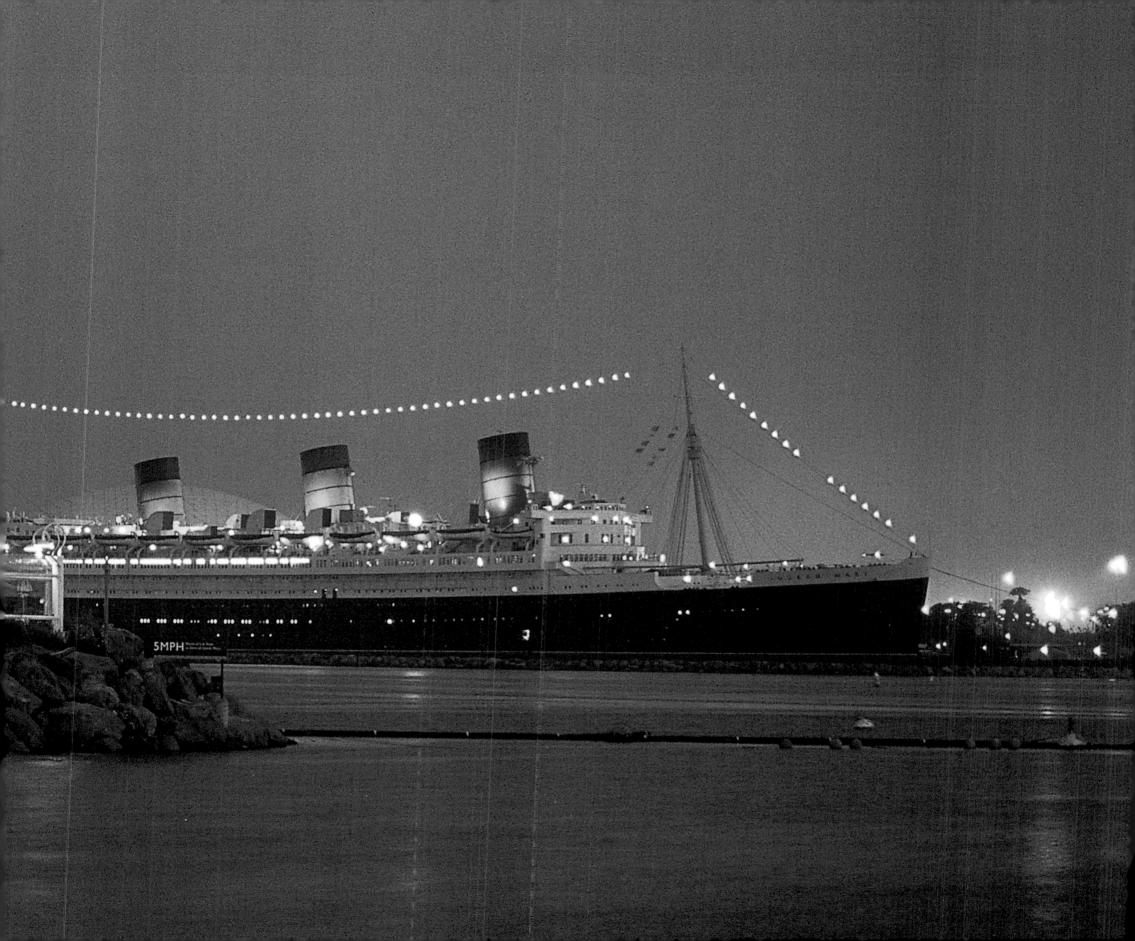

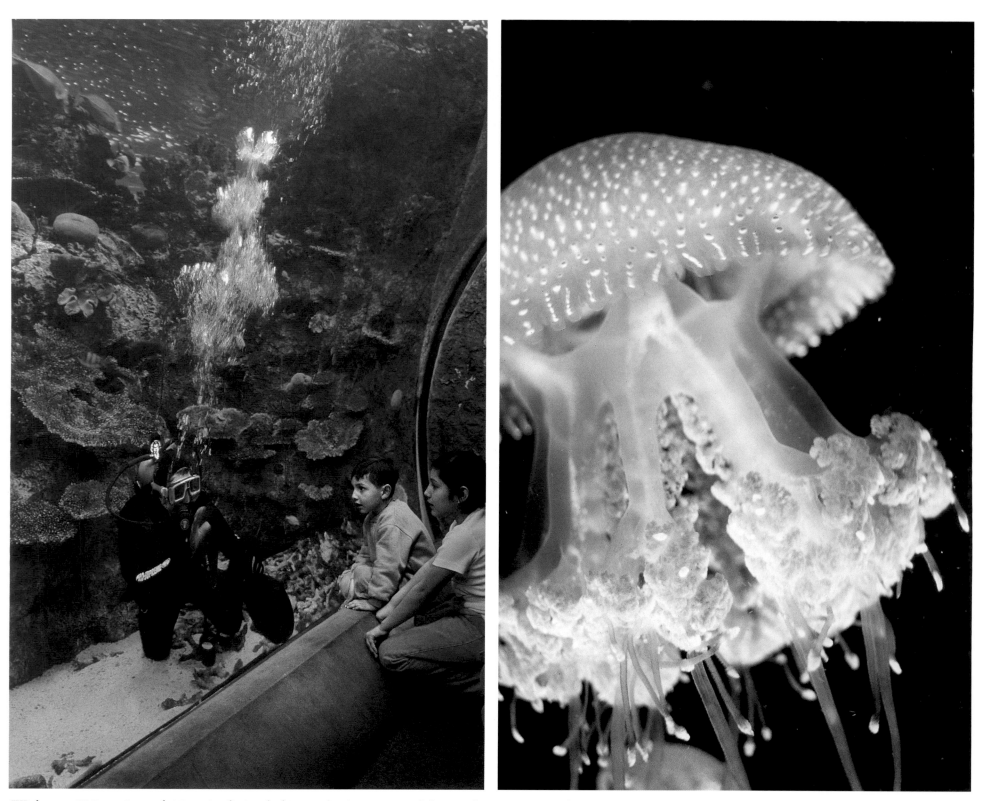

With over 500 species and 17 major living habitats, the Aquarium of the Pacific in Long Beach is one of the country's largest aquariums.

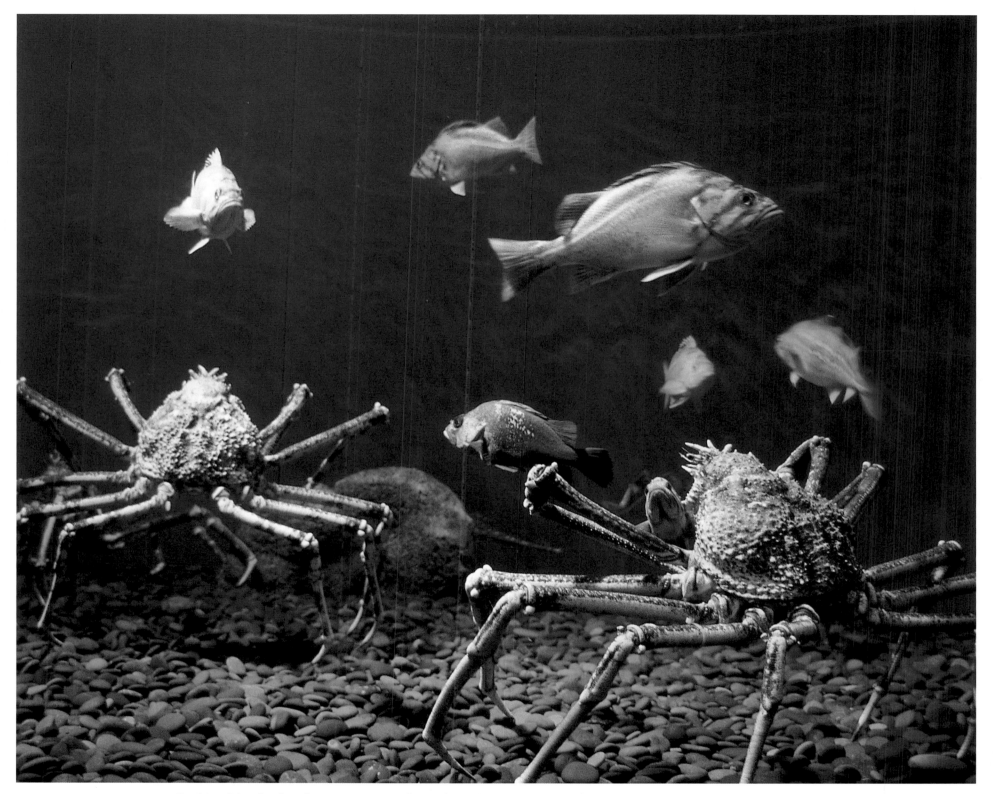

Looking like the face-hugging creature from Alien *(1979), giant spider crabs patrol the deep blue waters at the Aquarium of the Pacific.*

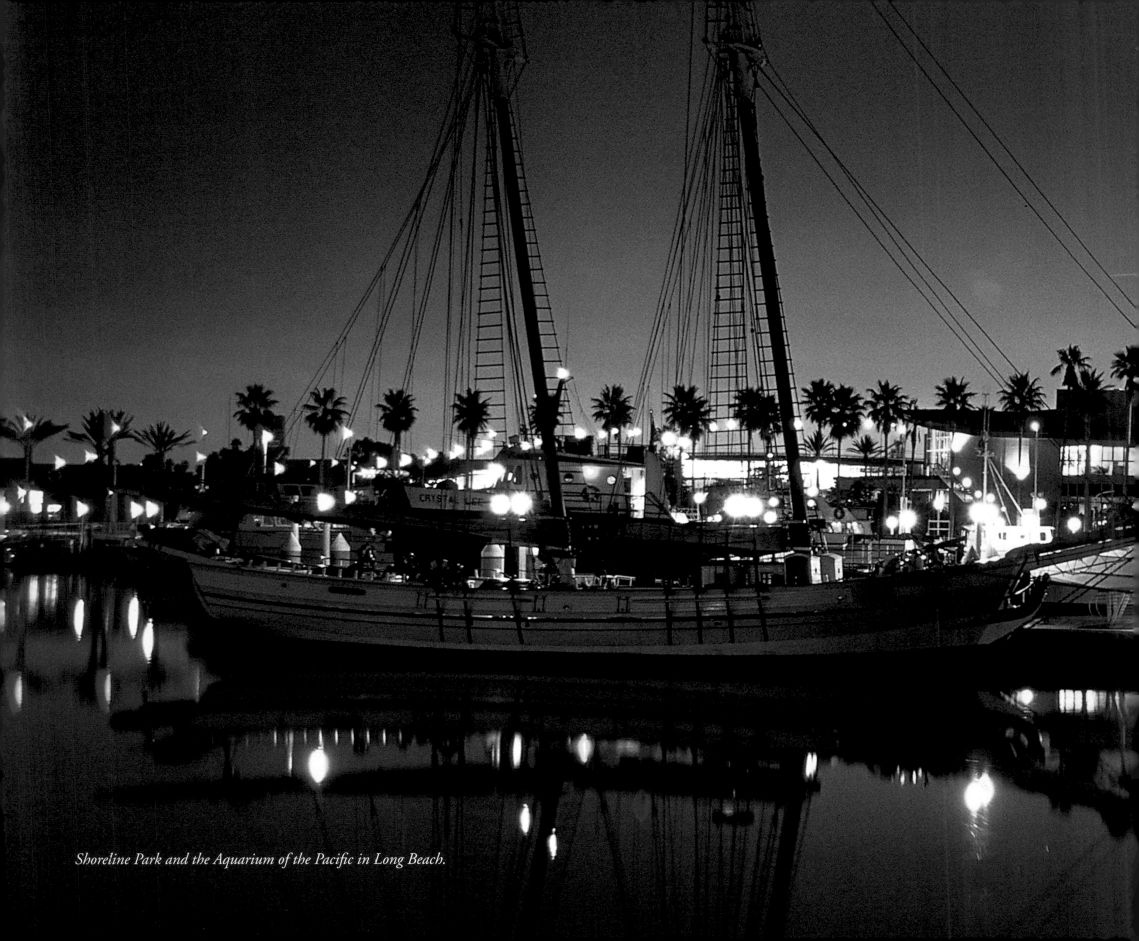

Shoreline Park and the Aquarium of the Pacific in Long Beach.

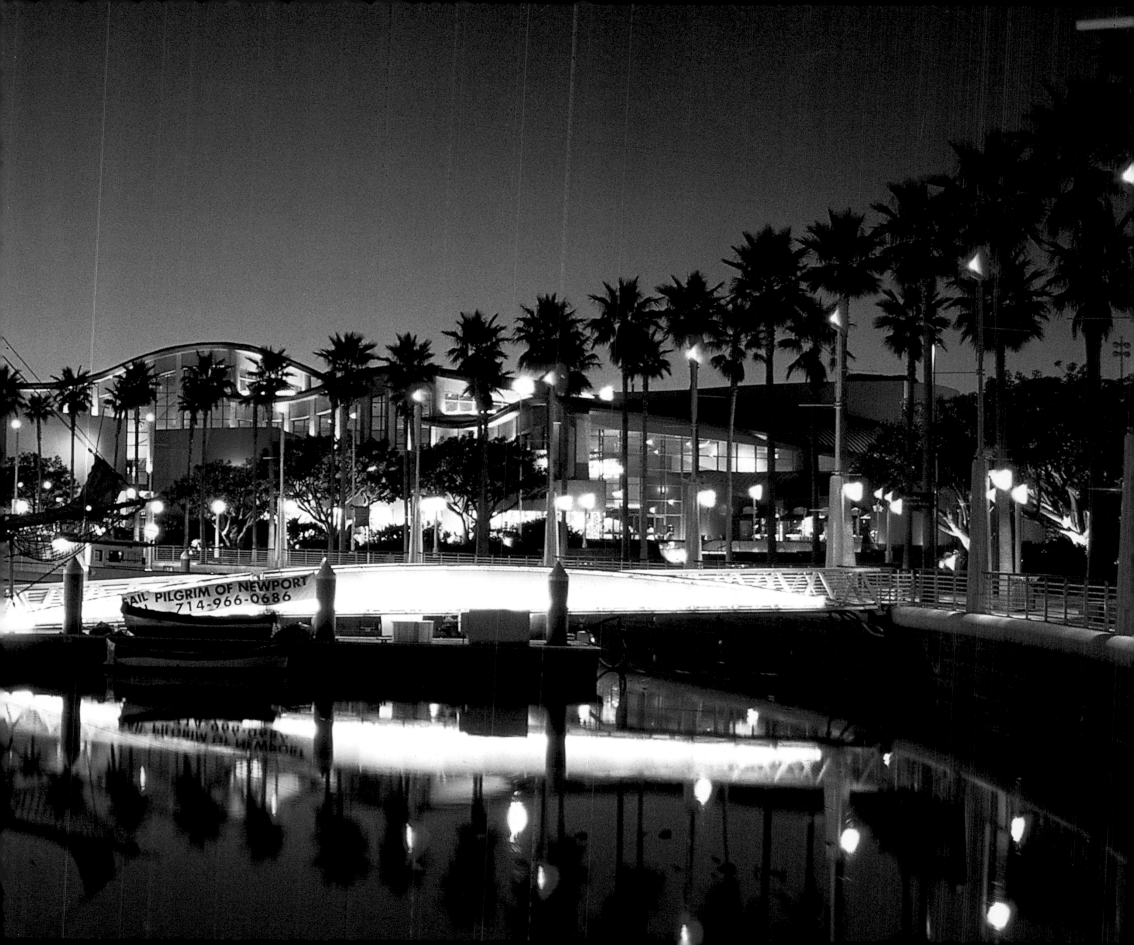

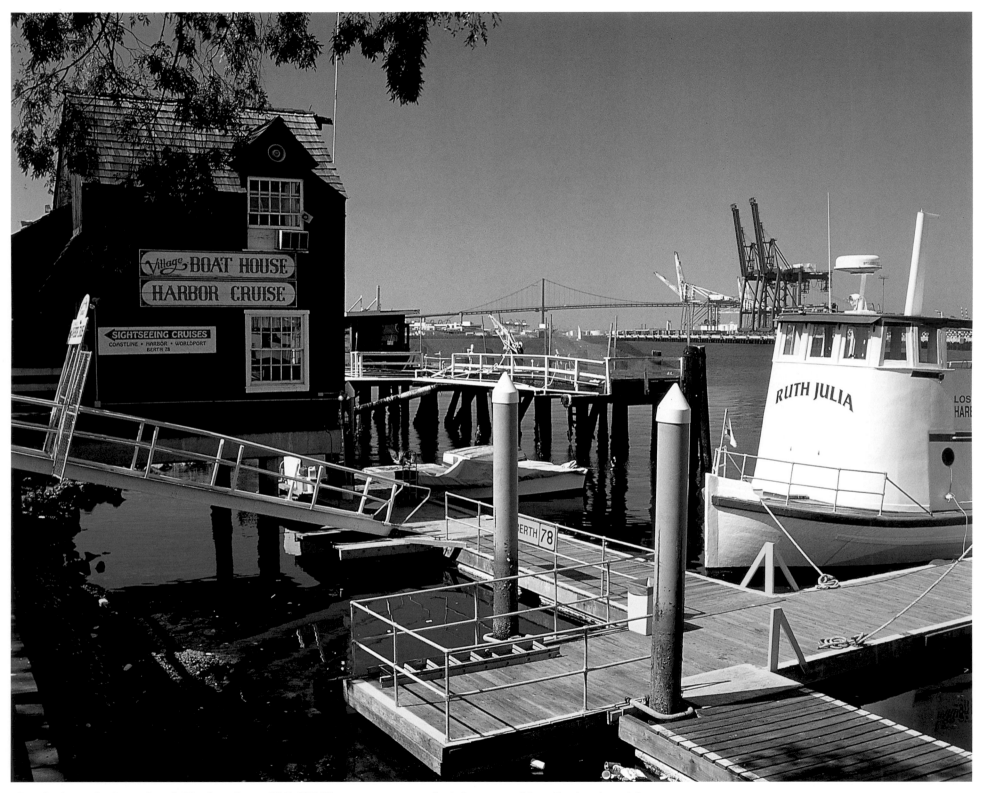

Overlooking the Long Beach Harbor, Ports O'Call Village is a re-created 19th-century New England seaside town.

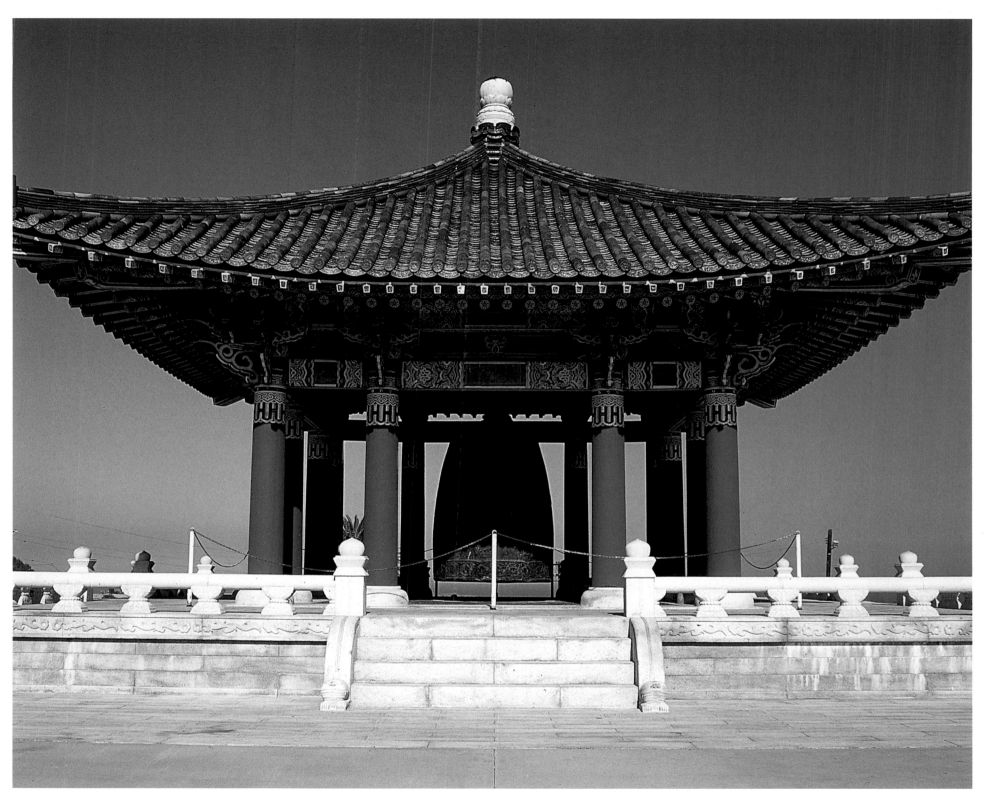

Patterned after a king's 8th-century bronze bell, the 17-ton Korean Friendship Bell in San Pedro was featured in the film The Usual Suspects.

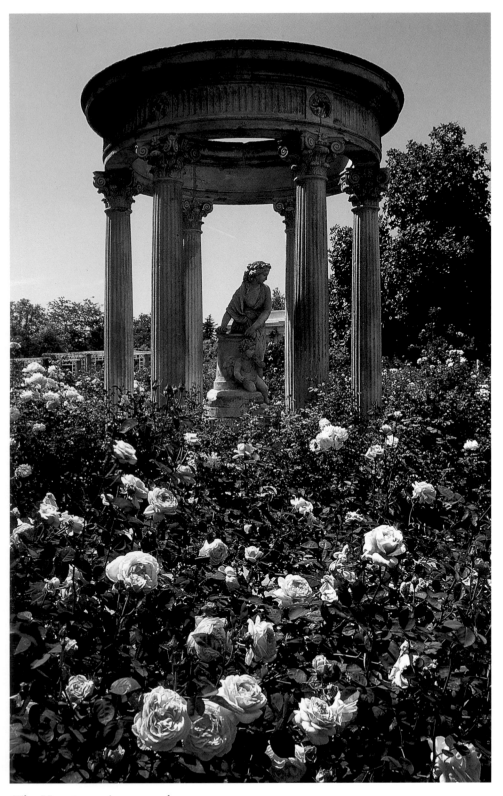

The Huntington's rose garden.

The Huntington

"I believe that Los Angeles is destined to become the most important city in the country, if not the world."
— *Henry E Huntington.*

Ten miles from downtown Los Angeles lies the Huntington, a 150-acre botanical oasis and one of the world's most impressive private cultural institutions. Inheriting most of his uncle's railroad fortune — and marrying his uncle's widow, Arabella — Henry E. Huntington became Southern California's largest landowner and developer. In 1919, he gifted much of his San Marino estate to the public.

The renowned library includes the Ellesmere manuscript of Chaucer's *The Canterbury Tales* (c.1410), the Gutenberg Bible (c.1455), and Benjamin Franklin's handwritten autobiography. The magnificent gardens display over 15,000 plant species from all over the world. Highlights are an authentic Japanese garden, one of the largest collections of camellias, the country's most extensive desert garden, and the delightful three-acre rose garden. After enjoying all the culture, relax with a traditional English high tea served in the Rose Garden Tea Room.

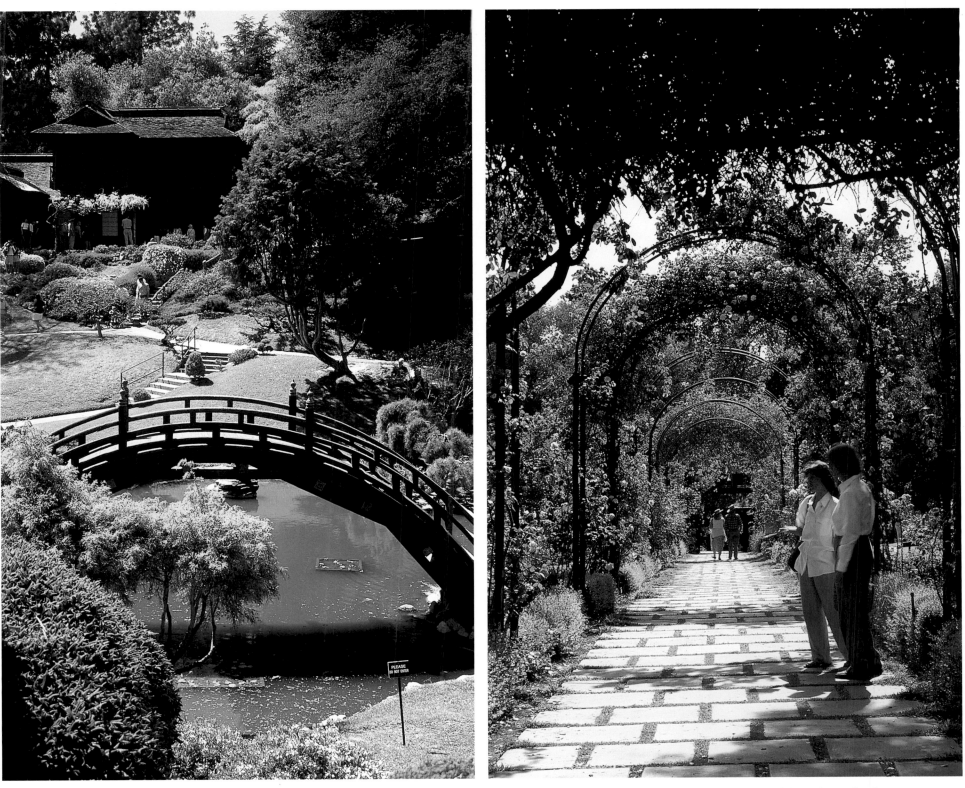

Enjoy a day in Japan, England or (overleaf) Italy, in the beautiful gardens of The Huntington.

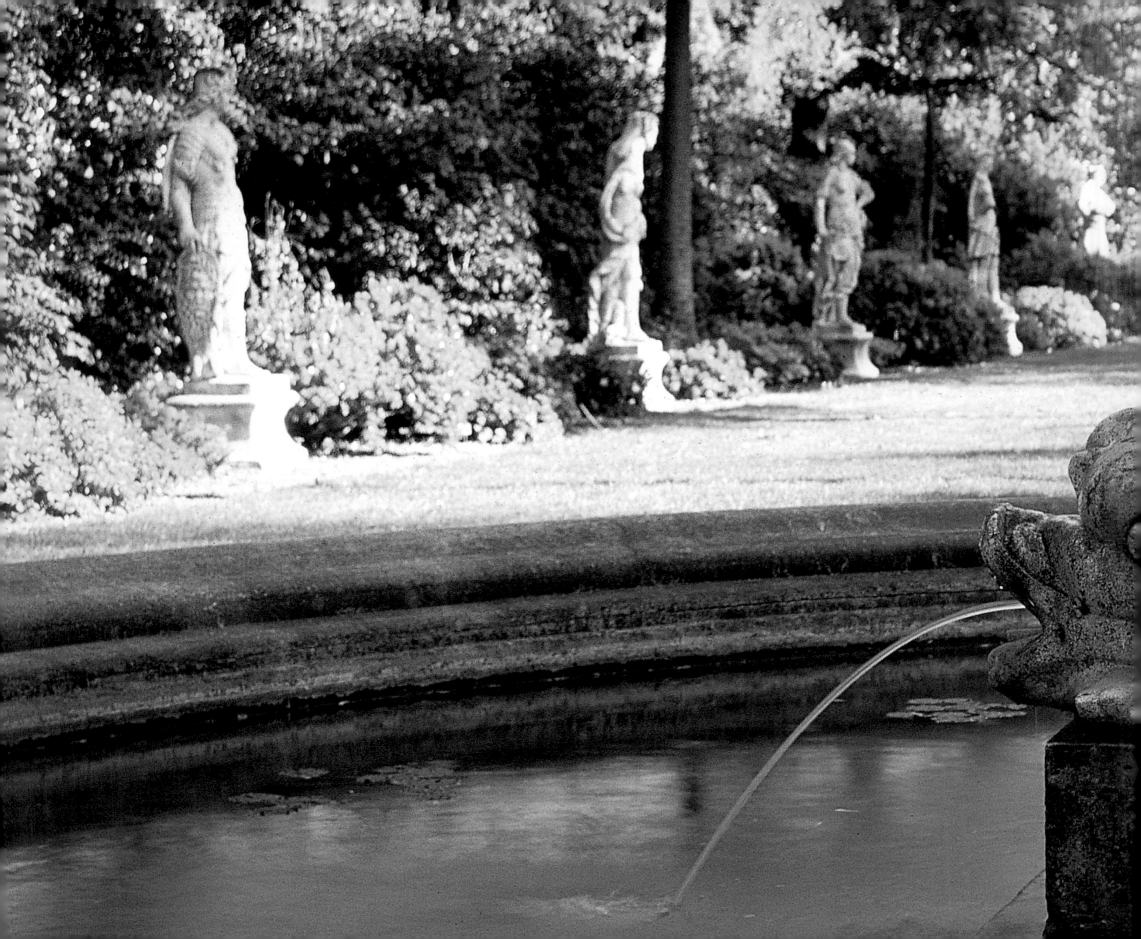

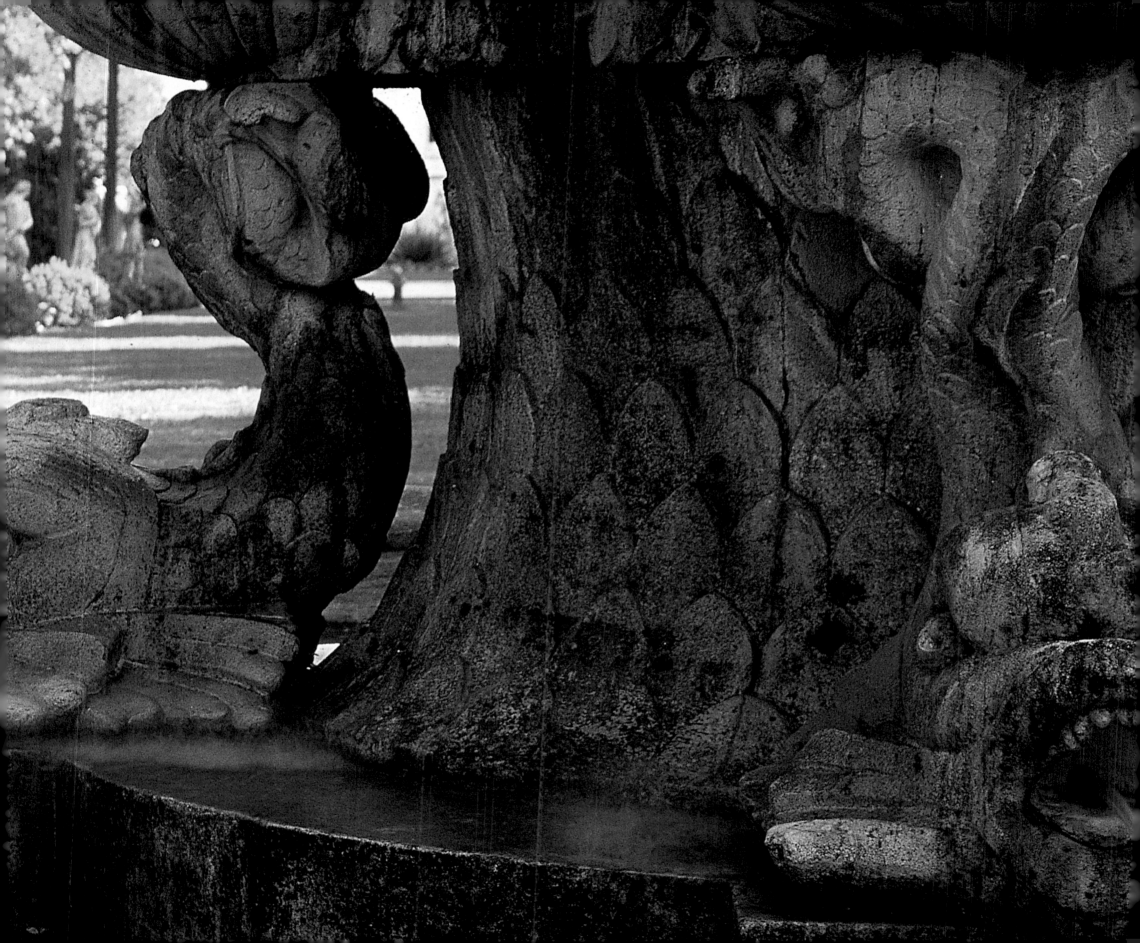

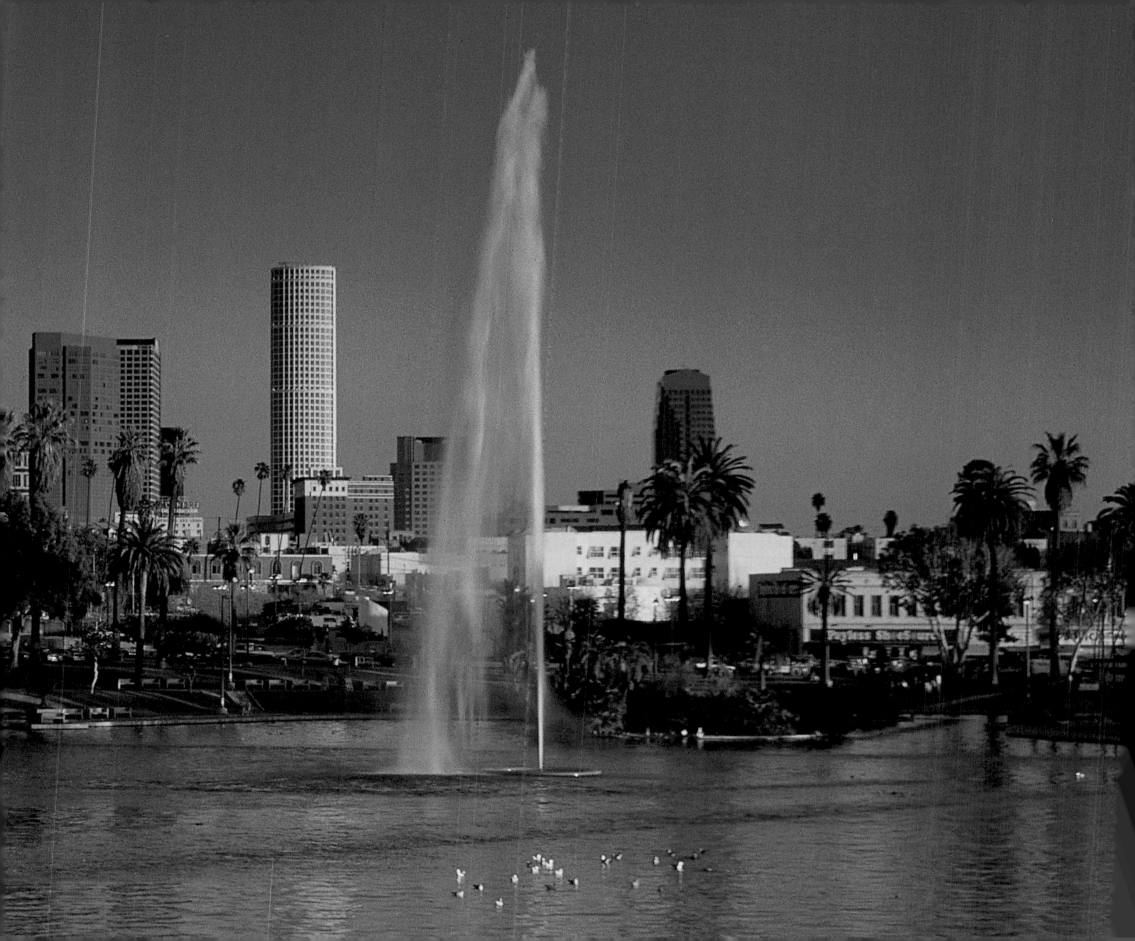

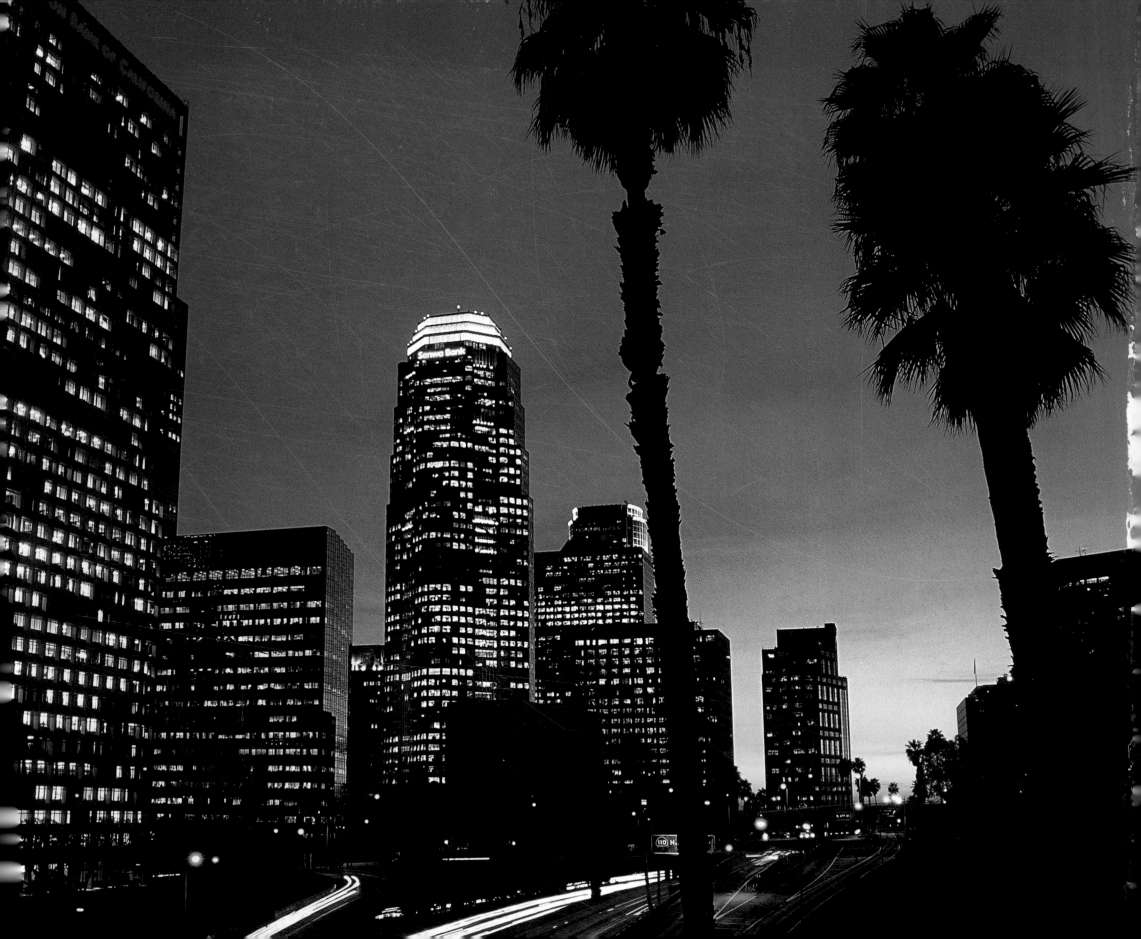